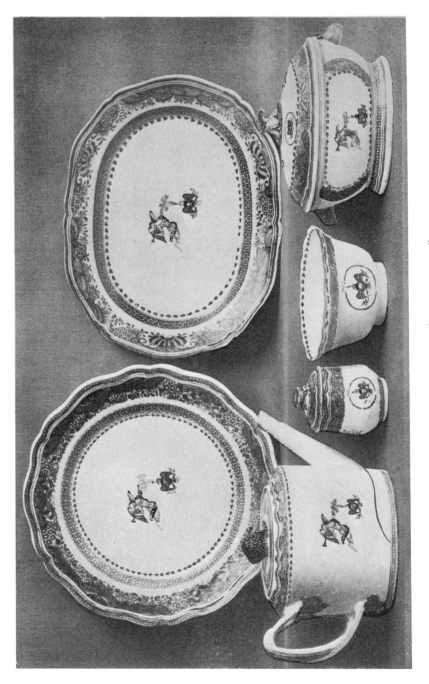

GENERAL WASHINGTON'S "CINCINNATI" CHINA

PICTURES OF
EARLY NEW YORK
ON DARK BLUE
STAFFORDSHIRE
POTTERY

TOGETHER WITH PICTURES OF
BOSTON AND NEW ENGLAND, PHILADELPHIA,
THE SOUTH AND WEST

R. T. HAINES HALSEY

With a new introduction by Marvin D. Schwartz

DOVER PUBLICATIONS, INC.

NEW YORK

Published in Canada by General Publishing Company, Ltd., 30 Lesmill Road, Don Mills, Toronto, Ontario.
Published in the United Kingdom by Constable and Company, Ltd., 10 Orange Street, London WC 2.

This Dover edition, first published in 1974, is an unabridged republication of the work originally published by Dodd, Mead and Company, New York, in 1899. In this reprint edition, which contains a new introductory essay by Marvin D. Schwartz, the illustrations are reproduced as black-and-white half-tones, whereas in the original edition they appeared as colored engravings.

International Standard Book Number: 0-486-21950-X
Library of Congress Catalog Card Number: 73-77376

Manufactured in the United States of America
Dover Publications, Inc.
180 Varick Street
New York, N. Y. 10014

INTRODUCTION TO THE DOVER EDITION

In spite of the fact that 1899 is the date of the original copyright of this book, it still remains one of the most interesting and timely accounts of a ware, made in the Staffordshire region of England and decorated with American scenes, that was extremely popular in the United States between about 1820 and 1860. Although later studies have been more precise about the sources of the illustrations and the identification of the potters who were making the ware, no writer since Halsey has been more enthusiastic or shown more knowledge of the subjects depicted.

The author, Richard Townley Haines Halsey (1865-1942), was a man of broad interests and one of the pioneers in the study of Americana. His most significant contribution was in helping with the organization and development of the American Wing of the Metropolitan Museum. He was instrumental in the earliest acquisitions of American decorative arts by the museum and very influential in the actual construction of the Wing, which was opened in 1924. Mr. Halsey's *Handbook to the American Wing* and its expanded version, *Homes of Our Ancestors,* relate American daily life to the arts in an innovative approach that was to serve as the model for any number of subsequent guides to historic houses.

Mr. Halsey had been an ardent student of American history when he graduated from Princeton in 1886. At first he pursued a career in finance while collecting and doing historic research as an avocation, but he retired fairly young to concentrate on his American studies. Interested in the arts rather generally, he wrote articles on furniture, pottery, textiles, silver, and painting. His catalog for the American silver show held in Boston in 1906 has served as a helpful guide to later students of the subject.

Mr. Halsey decided to write this book because he found blue Staffordshire a doubly fascinating subject. He was interested in the ware since it was handsome and serviceable, supplying the

widespread demand for inexpensive table services in the early nineteenth century. At the same time he was fascinated with the decoration, which he investigated with zeal. He wanted to place blue Staffordshire in its proper context in the evolution of ceramics, and he found the decoration as rich a source of American scenes as could be found anywhere.

While the Halsey account of the development of pottery has been modified in some detail, essentially it is correct. His discussions of the scenes are unusually informative and loaded with facts that are not easily learned from general source books. Mr. Halsey never simply talks about a picture as it appears on a piece of pottery, but rather he tells everything he knows that had occurred at a given place. He reminds his readers of seventeenth-century events as he discusses an early nineteenth-century scene. For example, the commentary on a plate showing City Hall in New York City includes facts about the Common where City Hall stands that remind his reader of seventeenth- and eighteenth-century events.

Besides making favored sites come alive by this delightful method of telling all about a number of specific places, Mr. Halsey offers the more usual assistance to collectors by listing every view known, and naming the potteries which produced the ware. He mentions over 200 of the close to 700 scenes that have been recorded.

Printed originally in an edition of 298 copies, the book was well-illustrated and intended as a monograph that would interest the curious as well as the collector. It was published the same year as Edwin Atlee Barber's study, *Anglo-American Pottery*, which was more specifically written with the collector in mind.

Collecting blue Staffordshire began just about as soon as the ware went out of fashion and was being moved from the pantry to the attic. As early as 1878, a book on collecting, *The China Hunters Club*, included a section on the ware; and it was equally prominent in the 1892 *China Collecting in America* by Alice Morse Earle. At that time it seemed to be of greater interest to Americans than English or continental collectors because it was most readily available in the United States. Each of the early writers under-

stood the place of the blue ware in the history of ceramics, and in most cases they expressed some esthetic appreciation for the ware; but only Mr. Halsey was able to discuss the significance of the illustrations in depth.

Since the Halsey book appeared there have been several studies published on the subject but none have superseded it. Ellouise Baker Larsen came very close to offering a complete catalog of every pattern made in her *American Historical Views of Staffordshire China* which was first published in 1939; however, she did not have the space to go into detailed discussions of the scenes.

The history of transferprint decoration, the technique employed on the blue ware, has been clarified since 1899, and it is now possible to change a few of the dates Mr. Halsey gives. The nineteenth-century historians attributed the introduction of the engraving technique to the Liverpool decorators, Sadler and Green. Today we know that the first patent application for transferprinting was made September 10, 1751 by an Irish engraver working in Birmingham, John Brooks (or Brookes). Brooks was associated with the enamel works at Battersea where a short time later the more famous transferprint engraver Robert Hancock was also active. Hancock moved to Worcester to work in the porcelain factory in 1756 when the Battersea factory went bankrupt. Sadler and Green were operating at full production by that time and were responsible for extensive transferprint decoration on tiles, but there is no way of substantiating their claim for being the first to use the transferprint technique.

Transferprinting was at first applied over the glaze so that colors were limited to black and red, whereas brown and purple were possible a short time later. Since blue had to be applied under the glaze it caused problems which were not solved until about 1760 when the first blue transferprint decorations were produced at the Worcester porcelain factory. Earthenware potters were not successful until more than a decade later. The Willow pattern designed by Thomas Minton in 1780 and introduced at Caughley as decoration for earthenware was the first underglaze blue transferprinted earthenware dinner service that is documented. R.

Badderly (more often referred to as Ralph Baddely), whom Halsey mentions, was experimenting with underglaze transfers in the 1770s; but he did not succeed until 1782. Spode, obtaining assistance from engravers who had worked at Worcester and Caughley, began producing the blue transfers in 1784 and soon became the largest manufacturer in the field.

The dark color and the smearing were results of difficulty in controlling the glaze, but the story of accidental discovery is very likely apocryphal. The potters did the best they could and their results were more self-consciously admired by a later generation than the group who bought it new and probably were settling for it because it was a bargain. Halsey and most collectors consider the wares produced between 1820 and 1840 to be the choicest, for they did not like the improved, lighter blues that followed the discoveries of new ways of controlling the glazes. Demand must have called for the additional colors of the 1840s and later, although most collectors are more interested in work from the period when only one color could be made. American views were made for sale in the United States, but the English potters tried to expand their market and produce wares with views from other parts of the world. As far as we know no other area was as receptive, and views of other countries are extremely rare.

Every writer is entitled to at least one good blunder, and Mr. Halsey's is a curious misinterpretation of a scene on a tankard. An illustration of a woodsman with an axe on a German tankard dated 1776 and bearing the initials "GW" convinced him that this was the first illustration of the cherry tree story. Historians insist the story was invented at the beginning of the nineteenth-century by Parson Weems, and so it appears highly unlikely that this scene has anything to do with George Washington's mythic childhood prank.

This book combines history, esthetics, and wisdom about collecting in a way that is inspiring. Good as a reference work, it is even better for the casual reader who can enjoy learning while having the pleasure of the eloquence of a skillful storyteller.

MARVIN D. SCHWARTZ

PREFACE

THE third decade of this century was very important in the development of this country's greatness. Trade, so heavily handicapped from the time of the embargo of President Jefferson, and destroyed by the War of 1812, was just reviving. A spirit of hopefulness and pride in the nation's progress took possession of the entire people.

Prior to the Revolution the Colonies had no ceramic history: the system of colonial government imposed upon our people was calculated to keep them dependent upon the manufactures of the mother country, and the wares sent here for sale were those commonly used in England.

The potter's art was practically unknown here. After independence was assured, the great potteries

of England still supplied our markets, and it was not until nearly half a century later that our potters attempted to furnish wares suitable for the table.

In the meantime direct trade with the East had been opened up and the American flag had become well known in the Orient. Part of the cargoes of the returning vessels consisted of table ware, and our enterprising merchants brought from China wares decorated to order with designs especially suitable for the American market.

For a number of years after the War of 1812 there was in this country a most intense hatred of England. The memories of the sufferings endured during the war for independence ; the actions of the English government in inciting the Barbary pirates to prey upon our growing commerce ; the state of unrest on our frontiers, stirred up by British emissaries, which resulted in several Indian wars; the atrocities of the press gangs, and the barbarous mode of warfare conducted by the British admirals upon our coast towns had engendered a feeling impossible to describe.

The joy in commercial circles upon the termination of the war was soon turned into despondency by the business depression caused by the enormous importations of goods from the overstocked markets of England. The sufferings of the whole country for the next few years were intense; so much so, that in cer-

tain parts of the country English goods were practically tabooed and the ordinary blue Canton ware was seen on every table.

With that keen insight which has given to the English manufacturer the markets of the world, several of the Staffordshire potters, instead of attempting to educate the people to stifle their prejudices, sent to this country for views of well-known buildings, and scenes which were regarded with pride. These were applied to earthenware by the transfer process then in common use. The blue colorings were chosen as they had previously proved attractive to American housewives, and were also the richest form of cheap decoration in use at the time.

The success of this style of decoration was instantaneous; and to the Staffordshire potters we are indebted for more than two hundred faithful views of our country, many of which have been perpetuated in no other way. Of these a large number are illustrative of the history of New York City and State.

I became attracted to this pottery through my interest in local history. Investigation soon showed that most of the scenes decorating the earthenware were taken from contemporary prints, which were most carefully copied and transferred to the earthenware, the only difference between the ceramic pictures and the original prints being that in the former the fore-

grounds were oftentimes altered to fit the various surfaces to which the copper-plate engravings were applied. Careful search also led me to believe that in a number of cases original sketches by artists were used, and that in this form alone numerous early views of our buildings and scenes have been preserved.

On tracing the date of the prints from which the potters took these designs, I was confirmed in my idea that none of this special kind of earthenware was made before 1821, contrary to the opinion prevalent among ceramic authorities. This conclusion is strengthened by the fact that such pottery was usually sent to this country in large sets, of which each piece was decorated with the same border. The various articles, however, generally portrayed different buildings, which, for the most part, were erected early in the century, though in some cases even as late as 1828.

In 1831 the process of lithography so cheapened the decoration of pottery that the beautiful dark blue was superseded by lighter colorings, which are decidedly inferior in artistic beauty to those printed from the deeply cut copper plate.

Too much stress cannot be laid upon the fact that this pottery was not made for sale as souvenirs. It was the tableware of the great middle class throughout this country. It is the exception to find one of these plates with its glaze unmarred by the marks of the knife.

There were few illustrated magazines in those days, and traveling was difficult and expensive, hence the only pictures of the great public buildings, steamboats and railroads seen by many of the residents of the more remote parts of this country were upon pieces of the table service. This dark blue pottery was made exclusively for the American market; even the ware ornamented with foreign scenes being mainly sold in this country. English writers on ceramics do not mention the ware decorated with these views; English antique shops do not expose it for sale. Even the great ceramic collections of England, both public and private, possess few, if any, specimens of the ware which in coloring almost rivals the priceless productions of the Orient. It must certainly be classed as Americana, and is a valuable contribution to the history of the nation.

The object of this volume is threefold.

First, I purpose to give a short account of the pottery used in this country with a view of showing the various stages of the decorative process, which finally led to the selection of designs, the subjects of which are taken from our national life.

Second, I endeavor to give some of the reasons why the decorations on this pottery appealed to the purchasers.

Third, I attempt to recall certain memories of the

past, when this country was starting upon its career of social progress.

In Appendix C is to be found a list of the various pieces of dark blue Staffordshire pottery decorated with designs relating to our nation's history. I have made every effort not only to make this list complete, but also to state in it the sizes and forms of the various pieces and, when possible, by whom they were made.

The present volume mainly treats of such pieces of this earthenware as illustrate the buildings, scenes, and incidents in the history of the City of New York. The brief space at my disposal prevents any extensive story of the great buildings that contributed so much toward making New York the metropolis of this country, yet I have endeavored to bring forward in condensed form many facts to which local historians have not referred. The views of interest throughout the State have been merely enumerated.

My original intention was to confine this volume to the pottery picturing scenes in New York City and State. It has been deemed best that I should briefly describe the wares decorated with views of other portions of the country as well. The illustrations accompanying the text are made from photographic negatives which I have made, and are largely reproductions of pieces in the collection which my wife and I have gathered together. Unfortunately the camera has

been unable to reproduce the superb glaze which covers the surface of these wares. The ten-inch dinner plates are shown in the largest illustrations, while the breakfast, tea and cup plates appear in the smaller pictures. Another standard of size is chosen for the platters.

The preparation of this work has been made doubly delightful by the many and valued friendships formed with those collectors who have most generously placed at my disposal their treasured collections of both pottery and prints. To these friends I am most grateful.

NEW YORK, October 28th, 1898.

TO MY COMPANION IN COLLECTING

H. E. H.

WITHOUT WHOSE UNTIRING ASSISTANCE
IN THE PREPARATION OF THE MANU-
SCRIPT AND THE MAKING OF THE
PHOTOGRAPHS THIS VOLUME
COULD NOT HAVE BEEN
COMPLETED

CONTENTS

CONTENTS

LIST OF ILLUSTRATIONS

LIST OF ILLUSTRATIONS

LIST OF ILLUSTRATIONS

THE MARKS OF THE POTTERS

PICTURES OF EARLY NEW YORK
ON
DARK BLUE STAFFORDSHIRE POTTERY

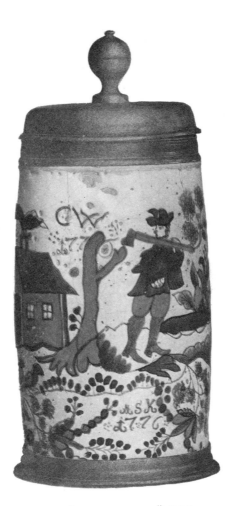

THE "CHERRY TREE" MUG

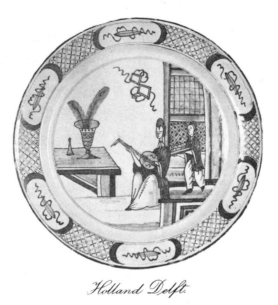

Holland Delft.

THE EVOLUTION OF THE BLUE PLATE

THE conditions under which the early settlements in this country were founded were not conducive to a lavish use of pottery as table furniture. The first imported porcelains and earthenware dishes were Oriental. The Dutch East India Company had at this time an extensive trade with the East, and the colonists from Holland undoubtedly secured from its merchants porcelains made in China ; the name China, therefore, soon became the generic term for all tableware made by the worker in clay.

These porcelains were of that dark blue so extensively used in China from the middle of the fifteenth century. The Dutch attempted to imitate them, and at the end of the sixteenth century several potters at Delft claimed to have found the secret of making porcelain, in which they were mistaken. They succeeded, however, in producing, in imitation of the Chinese, earthenware covered with a heavy coating of white enamel, and decorated with blue reproductions of the various Chinese designs.

The elongated women on the old Chinese porcelains immediately furnished a favorite pattern ; for the honest old Dutchmen fancied that these caricatured the well-known proportions of England's famous queen, to whom the people of Holland did not bear the most kindly feelings, and the "long Eliza" pattern was used by many potters and for many years.

The success of the Dutch potteries was so great that attempts to imitate their ware were made in England as early as 1640. However, the non-absorbent qualities of the English clay refused to retain the thick coating of enamel, and, therefore, the red color of the earthenware shows through the glaze, giving the English Delft a rosy tint, which distinguishes it from the Holland Delft.

The coming of William and Mary, with their large

following from Holland, introduced Chinese porcelains into England. The palace at Hampton Court was filled with the Queen's collections, and a mania for the grotesquely decorated dark blue Chinese wares seized the nobility of England ; even statesmen and generals vying with each other in securing choice specimens. From that time forward the English potters made great use of this color in the ornamentation of pottery.

In course of time, as the colonists in this country prospered, many wealthy persons discarded their pewter plates and wooden trenchers (the ordinary tableware of the settlers) for earthenware, and many pieces of old Chinese and Delft have been handed down through generations as relics of Colonial days. However, pewter and wood commonly supplied the necessary table articles of all, except prosperous families, until after the Revolution. Orders were soon sent abroad for enormous table services, often comprising as many as four hundred pieces. The principal decorations of these consisted of the owner's initials, or coat-of-arms.

These sets were, invariably, of Chinese manufacture, but in some cases the specially-ordered designs were added in England.

After the War of the Revolution an active trade with China sprung up, and soon the ordinary blue-and-

white Canton was seen upon every table, while the wealthier families on state occasions invariably beautified their tables with the more richly-decorated Chinese wares, erroneously termed Lowestoft,* and which was considered "best china" in many a household during the next fifty years. Of the same origin was the set owned by Washington. (See Frontispiece.)

These pieces mark the introduction into this country of a new kind of decoration, namely, that which is national in character and sentiment. This set of china bears upon its face the insignia of the Order of the Cincinnati. The body of the ware is Chinese, of somewhat better quality than that commonly imported. The blue coloring lies beneath the glaze, while the central design was added after the set left the hands of the original decorator. (See Appendix B.)

Our national coat-of-arms became a popular pattern with the Chinese artist, and this design was followed by a crude representation of the arms of the State of New York, in which Justice and Liberty appear to be of celestial origin. The increasing merchant marine and the new navy furnished other designs, and vessels flying the flag of the United States appeared

*While, until recently, this was universally classed as Lowestoft, a study of the history of the many pieces of this ware proves that their original owners received them direct from China.

6

on many a punch bowl.

In the meantime, the potteries of England had made great advancement under the leadership of Wedgwood. The introduction of the transfer process of printing upon pottery by Messrs. Sadler & Green in Liverpool, and Robert Hancock in Worcester facili-

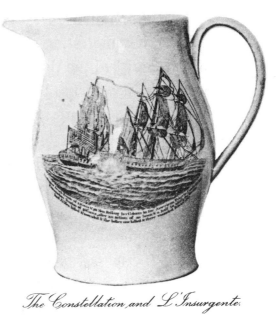

The Constellation and L'Insurgente.

tated the decoration of pottery in single colors. Following the early custom of using pottery as a means of perpetuating historical events and famous personages, a few years after the Revolution the English potters sent to this country articles of queensware which, on account of the decorations, proved exceedingly attractive to their rebellious cousins.

Many portraits of Washington appear upon large barrel-shaped pitchers, bowls, mugs and oval plaques. Pitchers bearing likenesses of John Hancock and Samuel Adams, "the Proscribed Patriots," also a map of

the United States guarded by Washington and Franklin and surmounted by a symbolic figure of Fame, afforded other interesting pictures. The death of Washington furnished the theme for a new series of designs, portraying the grief of the people and also the apotheosis of the great statesman; the naval victories of the French War appeared on numerous pieces, and the Bombardment of Tripoli and a portrait of Preble often decorated the two sides of a pitcher. Thomas Jefferson did not escape, nor did his successor, Madison; and the achievements of the Navy during the War of 1812, as well as the heroes of land and sea, are represented on the common cream-colored pitchers with which taverns and kitchens were well supplied from the potteries of Liverpool and Staffordshire.* An attempt was made to color this ware, the colors being added by hand with very crude results.

The black printing upon queensware left much to be desired, and interfered little with the painters in blue who followed their art in Staffordshire.

An attempt was made to facilitate the process of

* These barrel-shaped pitchers are generally considered to have been made at the Herculaneum Pottery, Liverpool. I have in my possession a nut-bowl of queensware, upon the bottom of which is impressed the mark "Wedgwood." The interior decoration of this, a chain composed of a series of links each bearing the name of one of the original states, is also found upon a number of these unmarked pitchers. It is probable therefore that many of the latter came from the pottery at Etruria.

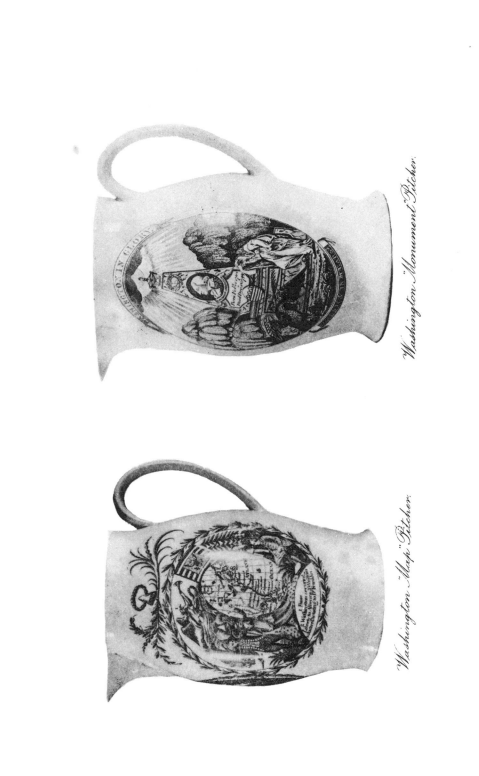

Washington "Monument" Pitcher.

Washington "Map" Pitcher.

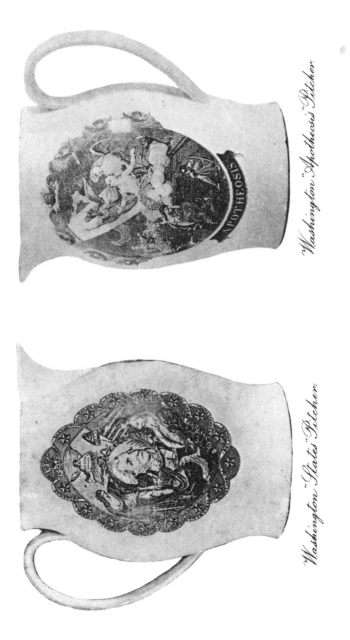

Washington "Apotheosis" Pitcher.

Washington "States" Pitcher.

blue painting—the most common form of color decoration on pottery. About 1775, one William Davis, at Cobridge, England, invented the glue bat, by means of which an outline of the design was printed, which outline was then quickly filled in with the decorator's color.

In 1780, Thomas Turner, of Caughley, completed the first blue-printed dinner-set, and four years later Josiah Spode introduced blue-printing into Stoke, and used the improved methods employed at Shelton by R. Badderly, whose work was unrivalled. Spode's first printed designs were variations of the willow pattern, a nondescript design which Thomas Turner had evolved in 1780 from several Chinese plates. He scattered birds, trees, boats, and pagodas over the surface with a view of covering, as far as possible, the white face of the object and adding richness of color.

This innovation in the decorator's art caused great distress to the large number of persons who were obtaining their livelihood from the blue painting. They went in a body to Wedgwood and asked him to use his influence to prevent the introduction of this new process, and worked upon his sympathies to such a degree that he replied : " I will give you my word as a man that I have not made, neither will I make, any blue-printed earthenware ; " which promise was kept.

The earliest method of blue-printing produced crude results, as we have already noticed. The design was printed from an engraved copper-plate upon a piece of heavy paper which was pressed down upon the surface of the earthenware and instantly removed,

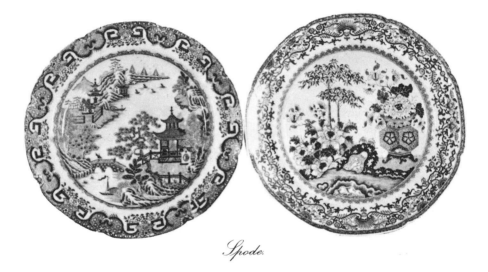

Spode.

leaving a coarse and blurred impression. So quickly did the paper have to be removed that in decorating pieces over a certain size the printing was done in sections.

Thomas Turner first conceived the idea of dampening the paper, and this greatly added to the clear-

ness of the impression. Subsequently, J. Greatbatch, a potter in the employ of R. Badderly, greatly improved the quality of the earthenware by mixing growan stone with the material that formed the body of the ware, and also by the addition of a little cobalt to the frit of which the glaze was composed. The next advance in printing was made by the introduction of oil into the coloring matter, and the new process as then practised is, with slight improvements, that in use to-day.

This method may be concisely stated as follows. The design is first engraved upon a flat surface of copper; the printer, having mixed the coloring matter with a stiff oil, spreads it with his palette knife upon the carefully warmed copper-plate. This coloring matter is so thick that it can only be used when warmed. After the plate is thoroughly filled and cleaned, it is put in the press and covered with a piece of tissue paper well moistened with a solution of soap and water. An impression is then taken and the printed tissue paper is ready for the transferer, who, after trimming and shaping it for the required surface, carefully presses it upon the ware which has been already covered with a very thin coating of varnish to insure the adhesion of the print. The ware is then immersed in cold water. The color, suddenly chilled by the water, becomes hardened and remains on the pottery, while

the paper floats away. After the oil in the coloring has been carefully dried out, the ware is ready for the oven, where it receives its glaze.*

Glaze may be described as a thin covering of glass, which protects the decoration and prevents the body of the ware from being discolored by the absorption of acids and greases.

In 1802 William Brookes, an engraver of Tunstall, suggested to J. Clive, a designer, the use of a highly decorated border, to serve as a frame for the central picture. This idea was quickly adopted, and each manufacturer soon made use of characteristic border-designs, which were never copied by rivals and which are the means of identifying the maker of many an unmarked specimen. The design for the first of these borders was suggested to Brookes by a slip of wall paper. The same engraver at a later period introduced the custom of using one ornamental border for entire sets of pottery in which each separate size of plate and dish had its own characteristic embellishment in the centre.

* The crudeness of this process necessarily caused great variations in the clearness of the design and in the richness of the coloring on pieces bearing the same decoration.

While I have endeavored to make my photographs for the illustrations in this volume from the finest specimens to be found, yet in certain cases the only examples I have been able to place before my camera are far below the standard set by these great Staffordshire printers upon clay.

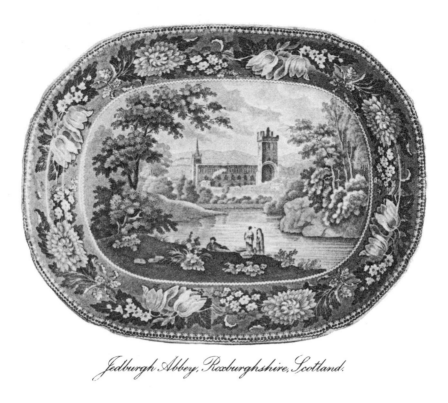

Jedburgh Abbey, Roxburghshire, Scotland.

One more stage of this decoration in blue remains to be described, namely, that of the use of the dark flowing blue which is peculiar to much of the pottery described in the following chapters. A medium shade of blue had already been in common use, and the engraving was so arranged that portions of the white face of the plates were left uncovered. The introduction of the deep colorings, which covered the entire surface of the ware, was, like many other advances in the potter's art, due to an accident.

Authorities generally agree that this dark blue coloring was designed to cover the entire surface of the pottery to hide the blemishes in the earthenware, which was of the cheapest description; yet they take no account of the fact that blue-printing was the common form of decoration found on the cheapest kind of Staffordshire pottery for many years before the special manufacture of this ware for the American market. The ordinary Staffordshire ware shows neither the rich dark color nor more than a portion of the surface covered by the printer.

While visiting the potteries at Trenton nearly twenty years ago, Mr. William C. Prime found an aged Englishman, who, being asked about the dark blue pottery of Staffordshire, related from his own experience the following story which Mr. Prime accepted as the origin of the dark blue decoration. One day some potters, on taking their wares from the oven, found that the blue coloring had overflowed the surface, nearly obliterating the design. The foreman considered the day's work a failure, but the owner, who chanced to be passing, thought differently, and said: "Oh, they will do for the American market." Much to his surprise the consignment sold instantly upon arrival, and a large order sent for a similar lot non-plussed the potter; for his success was the result of a mishap.

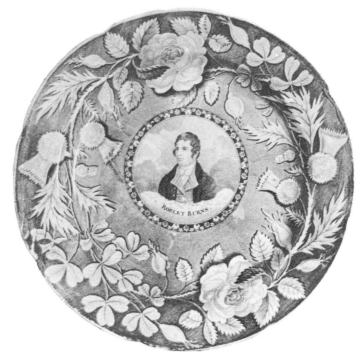

Robert Burns.

Rochester Castle, England.

After many experiments it was found that by cutting deep lines in the copper-plate, upon which the engraving was made, large quantities of blue could be printed upon the tissue paper and thence transferred to the earthenware. In the final process of glazing the blue flowed over the whole surface of the pottery, resulting in the flowing dark blue ware which so delighted the American purchasers.

The decorations on the blue-printed wares made in Staffordshire for many years consisted mainly of flowers and designs copied from the Chinese. Not until after 1820 did the potteries make use of views taken from illustrations found in descriptive books of travel. The authority for this statement, which differs from what is commonly accepted, is found in Simeon Shaw's "History of the Staffordshire Potters," published in 1829. Mr. Shaw, whose whole life was spent among the potteries of Staffordshire, had a wide acquaintance with the members of this profession, and his authority must remain unquestioned.

I desire to call special attention to the numerous artistic borders which frame the early views of our country shown in the following pages. The various blendings of sea-shells and sea-weeds, oak leaves and acorns, roses and scrolls, grapes and vine leaves, all reflect highly the skill of the Staffordshire designers.

Roses, shamrock and thistles encircle the portrait of Robert Burns (see page 17). Another attractive border is made up of American eagles united with the roses of England. The various combinations of fruits and blossoms, and the delicate intermingling of the many old-fashioned flowers add greatly to the attractiveness of this pottery.

In addition to the pottery decorated with American views, many pieces ornamented with artistic bits of scenery and buildings, not only in England but in various parts of the world, were imported. These found a large sale among unprejudiced persons, who, attracted by the beauty of their workmanship and coloring, by purchasing them secured a cheap and beautiful tableware. There is a strong reason for believing that these foreign views were not used on pottery until the blue American views had established the popularity of this idea in decoration.

With few exceptions these pieces of pottery bear upon their backs the names of the scenes represented. The maker's mark is often stamped upon the back, though in many cases save for the characteristic border the authorship of these pieces would be unknown. Indeed, much of the English pottery, of all descriptions, sent to this market is without marks of identification. Mr. Llewellyn Jewitt, the great authority on the Cera-

mic Art in Great Britain, explains " that it was due to the intense antagonism of the Americans shown to anything emanating from the mother country."

I have endeavored to trace the various steps in the decoration of pottery which lead to the particular kind of ware, with its superb coloring and brilliant glaze, that has perpetuated many artistic and interesting pictures of the past when this country was beginning to develop its resources and build up its cities. The following pages will be devoted mainly to descriptions of the views in the City of New York chosen by the English potter, which, from their prominence, appealed to a people proud of the progress that their country was making.

Mr. William C. Prime is the first writer on ceramics who called attention to the value of this class of pottery, and many a collector owes his inspiration to the prophetic utterance made in his introduction to " The China Hunter's Club" (New York, 1878), in which he says :

" Transfer-printing has abundant illustration in old specimens, exhibiting the art in the last century. Later on, as our country began to have a history, the Ceramic Art began to do, what it has done in all ages and all civilized countries, illustrate in permanent pictures the events of history. With whatever disdain the col-

lector of Dresden and Sèvres may now look down on the blue-printed crockeries of Clews and Wood and Ridgway, the day will come when ceramic specimens showing our first steamboats, our first railways, the portraits of our distinguished statesmen, soldiers, and sailors, the openings of our canals, the various events of our wars, and our triumphs in peace, will rank in historical collections with the vases of Greece. And whatever then be the estimate of the art they exemplify, men will say: 'These show the tastes, these illustrate the home life, of the men and women who were the founders and rulers of the American Republic.'"

Battle of Bunker's Hill.

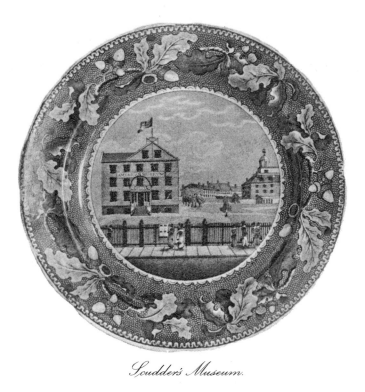

Scudder's Museum.

CITY HALL PARK

THE heart of the Bostonian thrills with patriotism when Faneuil Hall is mentioned. To Philadelphians the sight of Independence Hall is a constant reminder of the very remarkable body of men who gave to the world the Declaration of Independence.

It is seldom remembered by the residents of New

York that our City Hall Park, for a period of eleven years prior to the battle of Lexington, was the meeting-place of those citizens of this country who first resisted the oppressions of the British Ministry. Indeed, this place became famous throughout the Colonies as the scene of many meetings of the Sons of Liberty, an organization, which, although existing in various parts of the country, was most active in New York.

The Fields, or Commons, a portion of which is shown on the plate at the beginning of this chapter, was originally an oblong piece of ground bounded on the east and west by Nassau Street and Broadway. It extended to the north as far as the Collect, which at a later period was filled in and is now the site of the Tombs. What is now known as Ann Street marked the southern boundary of this bit of land. Diagonally through the lower end the Boston Post Road (Park Row) was laid out.

These "Common Lands" were originally granted to the Mayor for the use of the citizens by the Dongan Charter, dated April 22, 1686; they were first used as a common pasturage for the cattle belonging to residents of the town. The lower, as well as the extreme northern section, was, at various times, disposed of by the City Corporation. As early as 1686 a public building, the "Powder House," was erected on it, in which the

24

local merchants were compelled to store their surplus stocks of gunpowder, for the law allowed them to keep in their stores only a sufficient amount for daily sales.

In 1727 the City Gallows was removed there, and by its side seven years later the Alms House was built, a stone building, forty-six by twenty-four feet, and two stories high.

In 1757 the "New Gaol" was erected. The same year saw the building of the Barracks by the Corporation. This "house," as it was termed, stood in the northeastern section of the present park; it was four hundred and twenty feet long, twenty-one feet wide, and two stories high. It contained twenty rooms on each floor and quartered eight hundred troops, who in the next few years became most obnoxious in various ways to the citizens of the town.

At this period New York was dependent upon commerce for its livelihood, and many of its residents had, at various times, followed the sea. The impressment of sailors by the Royal Admiralty was particularly repulsive to them and had been endured for many years in silence.

This caused the first open act of rebellion against the forces of the Crown in 1764. The scene was the Fields.

The press-gang from the tender of one of the ships

on the Halifax station seized four local fishermen and carried them on board the vessel. The next day the captain of the ship ventured on shore, whereupon his boat was immediately seized, dragged to the Fields and burned. The terrified captain disclaimed all responsibility for the arrest of the fishermen and immediately wrote out an order for their release. This was obtained by certain of the citizens going aboard the tender and bringing back the victims in triumph.

From this time forward the Commons was the scene of many a remarkable meeting.

Here it was that on October 31st of the following year, the populace met while the merchants were signing the famous Non-Importation Agreement at the City Tavern.

The next evening an enormous mob gathered in the Fields, where a portable gallows was erected from which an unmistakable likeness of Governor Colden was suspended. Another effigy was paraded through the city by some of the citizens, who went to the Fort, broke open the Governor's carriage-house which stood outside of the ramparts, and, taking possession of his coach, seated the effigy in it. They dragged the coach up Broadway to their brethren in the Park. Joining forces, the procession marched back to the very doors of the Fort, and, before the eyes of the Governor

and Military, made a bonfire of effigies, gallows, coach, and all.

Such were the events of the first day of the Stamp Act. The following day another meeting was held in the Fields, when it was decided to march upon the Fort and seize the offensive stamped papers. This meeting was dissolved upon receipt of a message from the Governor, announcing that he had decided to await the coming of the new Governor, Sir Henry Moore, before attempting to put the Stamp Act in force.

Space does not allow the mention of the numerous meetings of the Sons of Liberty upon this historic Green, yet attention must be called to the great celebration of the King's birthday, which followed shortly after the repeal of the Stamp Act and which was carried out with great demonstrations of joy and loyalty to the King. The celebration was attended by the Governor, the principal officials of the city, and, practically, the whole populace. Two oxen were roasted whole and twenty barrels of strong beer were supplied. A barrel of rum furnished the principal ingredient of a punch, and a band of music added to the gaiety. An enormous bonfire was built around a mast, at the head of which were fastened twelve tar barrels.

A pole, erected near the soldiers' barracks, was in-

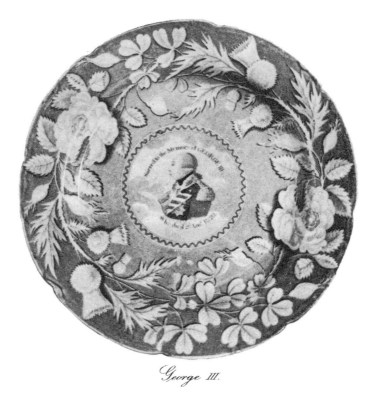

George III.

scribed "To His Most Gracious Majesty George the Third, Pitt and Liberty."

Such was the origin of the Liberty Pole, which became the scene of many a conflict with the British soldiery and came to stand for a principle as dear to the hearts of the Colonials as the right to avoid taxation without representation.

We will pass over the various contests between the citizens and the royal soldiery around the Liberty

Pole until the night of January 13, 1770, when the pole was cut down for the fourth time and its fragments piled up before Montague's tavern, Broadway and Murray Street, the headquarters of the Sons of Liberty.

The next morning some three thousand angry citizens assembled in the Fields to protest against this latest insult. Resolutions were passed declaring that all soldiers found armed in the streets after roll-call should be treated "as enemies to the peace of the City." A committee was appointed to enforce the resolutions. The next day three soldiers were caught in the act of posting hand-bills casting reflections upon the Sons of Liberty and signed "Sixteenth Regiment of Foot." These soldiers were arrested, and while they were being conducted to the Mayor's office in the City Hall in Wall Street, a rescue was attempted by their comrades, which resulted in the battle of Golden Hill, when the first blood of the Revolution was shed.

Upon the Mayor refusing to permit another pole to be erected on public property, a part of the Fields which was found to belong to private persons was purchased. The Liberty Pole erected upon the Commons near the corner of Broadway and Chambers Street stood until the capture of the city by the British troops, when this symbol of freedom was cut down by Provost General Cunningham.

The Fields on July 16, 1774, was the scene of another great meeting to voice the sentiment of the people, and here it was that Alexander Hamilton, still a boy, first took his place among statesmen, by means of his logic and eloquence. Here it was that two years later, while drilling his company of artillery, by his display of tactical skill, he attracted the soldierly eye of General Greene, who sought him out and introduced him to Washington.

On July 9, 1776, the Declaration of Independence was first read to the Continental Army headed by Washington and his staff, and drawn up in review upon the Commons.

Thirty-six years later this spot was the scene of another great meeting, when the citizens of New York while recognizing that the war just declared meant ruination to their interests, pledged their unanimous support to the National Government.

Two years afterward the citizens assembled there to take measures for the defence of the city then threatened by the invasion of the British.

The potter's art has preserved pictures of six buildings erected at various times upon the Commons, all of which have played most important parts in the development of the city.

Upon the plate marked " Scudder's Museum," the

building on the right was known at various periods as
" The New Gaol," " The Provost " and " The Debtors'
Prison," and is still preserved to us (remodelled) as the
Hall of Records. Erected in 1757, of rough stone, at a
cost of about fourteen thousand dollars, it was called
" The New Gaol," and, for a few years, was used to
confine all classes of prisoners whose habitation up to
this time had been in the City Hall, which stood on
the corner of Wall and Nassau Streets.

The architecture of the " Gaol " was of the style
commonly used for public buildings at the time. It
was three stories high, with a peculiar roof sloping
from each side toward the centre, and surmounted by a
belfry.

In the year 1763 it became the scene of a disturb-
ance which first brought the British soldiery into actual
conflict with the civil authorities. It seems that one
Major Rogers, a British officer who had cut quite a
swath in the staid colonial town, and had exhausted
his credit, was put into prison by the irate tradesmen
to whom he was indebted.

This action was resented as an insult by the sold-
iers and a rescue was planned. The soldiers attacked
the " Gaol " in the middle of the night, and, after a
severe struggle, unlocked the doors, giving freedom to
the unfortunates confined therein. To the Major's

credit, it must be said that he refused the liberty which was offered him.

Upon the capture of the city by the British, the building became a military prison and was given into the charge of one William Cunningham, a renegade Son of Liberty who had been appointed Provost General of the city. By means of his cruelty this Cunningham so branded his personality upon the building that even for many years after peace had been declared, the prison was commonly known as the "Provost."

Much has been written concerning the atrocious treatment of the American prisoners in New York by this man, and most of this is, undoubtedly, true. Still, it must be remembered that in the early part of the war the British officers at the command of the Ministry refused to grant to their opponents belligerent rights or even recognize the power of Congress to grant commissions. Rank was even refused to Washington. The prisoners were looked upon as traitors and rebels. Added to this, at its earlier stages the Revolution had somewhat the nature of a civil war; many of the Colonists espoused the Crown, and it is a well-known fact that the bitterest of all wars is that waged between a divided people. The Provost was a Bostonian born.

The position of the British army in New York was

not an enviable one. Upon the evacuation of the city by the American troops, a disastrous fire destroyed nearly one-third of the city's buildings and robbed the invading army of many a sorely needed habitation.

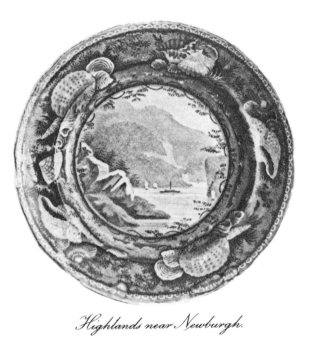

Highlands near Newburgh.

This undoubtedly explains the great crowding of the captured Americans into the few buildings which could be made available for prisons. Dependent for their supplies of provisions upon the ships from abroad, their foraging parties into the surrounding country being

mercilessly harassed by the vigilant Washington, the first winter spent in New York involved great suffering and hardship for both officers and men. It is only natural to suppose that when the royal commissaries were unable to supply their own troops with fire and food, that the luckless Americans who fell into their possession received merely the scantiest attention, especially in view of the fact that Congress and Washington had refused to make an exchange of prisoners. Still nothing can condone the wanton cruelties which this Cunningham inflicted upon the unfortunate prisoners who fell into his hands.

To the credit of the British Commander it must be said that upon complaint being made, and especially after the exchange of prisoners was allowed by Congress, the lot of the captured Continentals became more endurable, and the " Provost " soon became used for the confinement, not of American officers but of malefactors of both sexes who were brought in by the military patrol. After the war was over the building was devoted to even baser purposes than when under the infamous Cunningham. In these enlightened times it seems hard to understand the law which allowed a creditor to cause the arrest of an unfortunate debtor and confine him in the " Debtors' Prison " until he was released by the payment of the debt.

It certainly is no reflection upon the honesty of the times to read that between January and December of the year 1788 no less than eleven hundred and sixty-

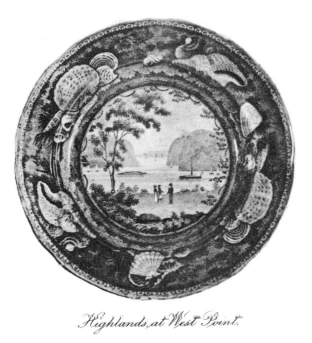

Highlands at West Point.

two persons, one-twentieth of the population of the city, were imprisoned for debts under ten dollars in amount.

The injustice of this law was so apparent that it is difficult to see how it could have been enforced. Let

35

a laborer fall ill, immediately upon his recovery he would be confined for debts incurred during his illness.

During the year 1809 there were confined eleven hundred and fifty-two persons, not one of whom owed as much as twenty-five dollars—five hundred and ninety-one of whom were held for debts under ten dollars. Under this cruel law " spite " actions were numerous and blackmail was encouraged. Yet neither City nor State made any provision for the entertainment of the unfortunates who were left to meditate, freeze and starve, dependent upon the bounty of their friends, if they had any.

In 1787 a Society for the Relief of Distressed Debtors was formed " having the melioration of the sufferings of that class in view." This society was dependent upon the voluntary contributions of its members, and such donations as were received from those in sympathy with its object. In 1803 its name was changed to that of the Humane Society, and in 1806 its scope was enlarged so as to include " the resuscitation of persons apparently dead from drowning." The directions for this act were extensively scattered abroad.

In the same year, assisted by the donation of a piece of ground and six hundred dollars in cash from the city, the Society erected a small building on Tryon

Row, familiarly known as the "Soup House," where meals for the unfortunate recipients of its bounty were prepared.

During the hard times caused by the Embargo, and for some time after the War of 1812, the resources of the Society were severely tested in alleviating the hunger of the starving poor of the city, to whom as many as one thousand quarts of soup were daily issued during times of the greatest distress.

The aims of the Humane Society were for nearly thirty years stated as follows :

"First : The support and clothing of debtors in prison, and as connected with the former the maintenance of a soup house establishment.

"Second : The liberation of such debtors as were by law entitled to be discharged, and of such as were confined for small sums and were particularly deserving of assistance.

"Third : The distribution of soup to the poor in general, especially in cases of general public calamity.

"Fourth : The resuscitation of persons apparently dead from drowning.

"A favorite object of the Society was also to discourage the practice of street begging."

The daily ration issued to the debtors by the Society consisted of half a pound of meat, two potatoes,

three pints of soup and an Indian-corn dumpling. Bedding was also provided, and, at times, fire-wood.

In 1817 a strong effort was made to secure the abolishment of the iniquitous law for the imprisonment of debtors.

In a petition to the Senate at Albany it is stated that during the year 1816 nineteen hundred and eighty-four debtors were confined, eleven hundred and twenty-nine of whom were for debts under fifty dollars, and of these seven hundred and twenty-nine were imprisoned for failure to pay amounts of less than twenty-five dollars. The sheriff of the county testified that every one of these unfortunates would have starved to death but for the kindness of the Humane Society.

The weight of the evidence of the inhumanity and injustice of this law was so overpowering that the Act was modified and only held those who were indebted for the sum of five hundred dollars. This led the way to more sensible legislation in regard to the protection of debtors.

In the belfry of this building the city fire-watch sat, and, after sounding the alarm, pointed the direction of the frequent fires with a pole and a flag; at night a lantern was substituted for the flag.

There being no longer use for a prison of this character, it was determined in 1830 to devote the building

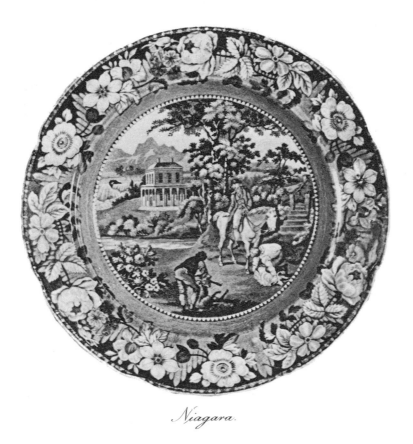

Niagara.

to other uses. The sloping roof, belfry, and part
of the upper story were taken off and replaced by a
flat copper roof. Ionic porticos and marble columns
were added to the front and rear, and the rough stone
walls were covered with white stucco. When newly
remodeled the building was very handsome and an or-
nament to the city. It was considered a perfect rep-
resentation of the temple of Diana of Ephesus.

In 1832, while the alterations were still being made, the city was visited with a frightful epidemic of cholera, and the old prison served as a hospital for those sufferers inflicted with the plague. Three years later the building was finished, the changes costing thirty thousand dollars. The new occupants were the Registrar, Comptroller, Commissioner of Streets, and Surrogate, all of whose offices remained in the building for over a generation. Lack of accommodation caused the removal of the Surrogate in the year 1858. The next year the Commissioner of Streets followed.

Ten years later the extravagance of the Tweed Ring furnished a new and costly home for the Comptroller in the new Court House. The eyes of this celebrated band of robbers were cast longingly upon the old prison. For the sum of one hundred and forty thousand dollars—more than nine times the original cost of the building—the roof was raised several feet, the south wall extended out to meet the Ionic columns, and a little fire-proofing was done in the interior.

Such is an outline of the history of this famous old building, and it is devoutly to be hoped that it will ever remain a silent witness to the stirring scenes which led to the city's greatness.

On the left of the same plate is to be seen another building, the Alms House, which, while not so filled

with historic reminiscences, played a most important part in the social development of the city.

It was erected in 1796 from the proceeds of a lottery issued by the City Fathers, probably the most expeditious way at the time to secure funds for the much needed public building. It could not be said that it was an architectural ornament to the Fields. The site chosen was what is now the northwest corner of the City Hall Park, and part of the building covered the ground which had been sold to some of the Sons of Liberty for the erection of their Pole. The structure was enormous for the time. The dimensions were two hundred and sixty feet long by forty-four broad, and it was three full stories in height, besides the basement. The material was brick.

In 1816 the paupers were removed to more commodious quarters at Bellevue. Then a different phase of the building's usefulness commenced. The far-seeing Corporation donated it to the use of the various literary and scientific societies of the city, rent free, and changed the name to that of the New York Institution.

Scudder's American Museum, whose unmistakable sign was plainly seen by pedestrians on Broadway, occupied the west wing of this reconverted building. Attention was also attracted by the Museum band,

which, stationed on the porch over the entrance, discoursed loud-sounding if not melodious airs. The history of this Museum is as follows:

In 1791, the Tammany Society, then largely a ben-

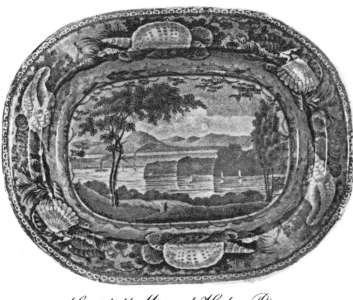

Catskill Mts. and Hudson River.

evolent institution, at the instance of John Pintard, decided to form an "American Museum for the purpose of collecting and preserving whatever may relate to the history of this country and also all other curiosities of nature and art." The city allowed it a room in the old City Hall. This was open to members of the So-

ciety at all hours, and to the public on Tuesdays and Thursdays.

In 1793 an advertisement of this Society states that there are on exhibition a number of live South American and Oriental animals and also "an American grey squirrel in a machine in which he grinds pepper for his living." At the time of this notice this first Menagerie and Museum was housed in the Exchange on the corner of Pearl Street facing the Battery.

The interest of the Tammany Society gradually turning from the purpose for which the Association was started, Mr. Pintard was allowed to sell the Museum in 1810 to a Dr. Scudder, who sold his collection in 1842 to P. T. Barnum. This became the foundation of Barnum's famous Museum. Dr. Scudder was a man of great enterprise and constantly replenished his stock of curiosities. In its palmy days the Museum was frequented by the best class of citizens, the ambitious owner placing upon sale yearly and family tickets for small sums.

The fame of the Museum soon spread throughout the country and its popularity was undoubted; it would be well if the authenticity of many of its wonderful relics, said to have been taken from natural, historical and sacred sources, were equally undoubted.

Such was the confidence in Dr. Scudder that the city intrusted him with the keeping of the American

flag, first hoisted at the Battery upon the day of the evacuation of the city by the British.

Among the various other occupants of the New York Institution were :

First, The Literary and Philosophical Society chartered in 1814 with the object, as stated in the memorial presented to the legislature, "to cultivate the most useful branches of knowledge, to stimulate into activity the literature and talents of the community, and by a concentration of men of different professions and various acquirements in one association, to collect a mass of various information which may have a tendency to elevate the literary character and subserve the best interests of our country."

Second, The New York Historical Society.

New York certainly owes a debt of gratitude to John Pintard. While at Princeton College under the tuition of John Witherspoon, of whom he was a friend as well as pupil, he became saturated with the same love of country and love of learning that distinguished his talented preceptor.

Shortly after the Revolution he recognized the necessity of preserving the records of the past, and impressed this fact upon his friends in Massachusetts. This effort led to the founding of the Massachusetts Historical Society in 1791.

Thirteen years later at his solicitation eleven re-
markable men, Judge Egbert Benson, Mayor DeWitt
Clinton, The Rev. Drs. Samuel Miller and John M. Ma-
son, John N. Abeel, William Linn, Dr. David Hosack,
Anthony Bleecker, Samuel Bayard, Peter G. Stuyvesant,
and John Pintard, sat in the picture room of the old
City Hall and agreed to form a society for the collection
and preservation of whatever might relate to the history
of the country in general and New York in particular.
Three weeks later they adopted a constitution for it.

Its first home was in the old City Hall. Five years
later it was assigned quarters in the Government House
on Bowling Green. In 1816 it was removed to the
New York Institution, where it remained for sixteen
years.

The Society played a most important part in the
social life of the city. The greatest honor showered
upon a distinguished guest was a reception given to
him at the home of the Society. The rooms served its
members as a gathering-place for social intercourse, and
its well-attended meetings always ended with a supper
for members and guests, which time-honored custom
is continued to-day.

Third, The American Academy of Fine Arts.

This Society, founded in 1801 by Robert Living-
ston, Ambassador to France, had its rooms in the New

York Institution. For a time it was quite prosperous ; however, it did not meet the requirements of the professional artists as it was conducted in a very high-handed manner, and the dissatisfaction with the management when John Trumbull was president culminated in the withdrawal in 1825 of a number of prominent artists under the leadership of S. F. B. Morse, who formed the Society well known to all New Yorkers as the Academy of Design.

Fourth, The Deaf and Dumb Institution.

Soon after the first Deaf and Dumb Asylum of this country was founded in Hartford in 1817, our New York Institution was incorporated, and for ten years it occupied several of the rooms in this building. Its support was derived from the fee paid the city by the dealers in lottery tickets.

Fifth, The Society for the encouragement of Faithful Domestic Servants, founded in 1825 to alleviate the sufferings of the Knickerbocker housewives. Strange to relate, it had a short existence.

" The primary object of the society was to offer liberal premiums to those domestics who conduct well and remain longest in a family and to remedy that restlessness and love of change in them which produces so much inconvenience to all housekeepers."

The method was to offer to the servants of the

subscribers a reward which was constantly increased with years of faithful service.

Probably the most useful institution housed in this building was the first Bank for Savings. Started as a

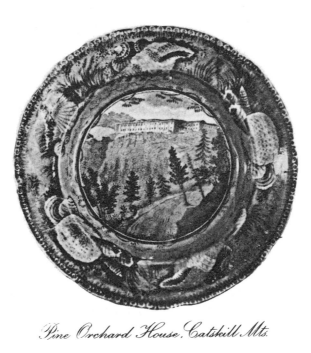

Pine Orchard House, Catskill Mts.

doubtful experiment in the year 1819, chiefly through the efforts of John Pintard, its success was instantaneous. The bank was open twice a week for the transaction of business. In the first year of its existence it entered upon its ledger the names of four thousand,

eight hundred and forty depositors, who were credited with the enormous sum for those times of $313,384.24. Outgrowing its accommodations six years later, it built a home on Chambers Street opposite the park ; after various changes of habitation it still continues its work in its princely building on Fourth Avenue and Twenty-second Street, a noble monument to the man to whose philanthropic spirit its origin was due.

The building just described, which sheltered so many of the prominent societies of the city in the early part of the century, was destroyed by fire in 1856.

The group of three small buildings seen in the background of the view, on this same plate, were all erected owing to the effort of citizens interested in bettering the condition of those less fortunate than themselves.

The building on the left was the first New York Dispensary. The New York Dispensary was not incorporated until 1795, although it had been suggested as early as 1790. For many years it occupied the building shown in the illustration ; and about the year 1830 the society moved its quarters to its present home in Centre Street.

The central building, the " Soup House," has been previously alluded to. To the right is seen a small portion of the first Public School erected in the city.

48

The great prevalence of illiteracy was often discussed by those who had the welfare of the future of the country at heart.

While numerous religious denominations had schools for the young of their faith, there was absolutely no means of education for the children of the poor who had no religious connection. The Society for " the establishing a Free School " in New York was incorporated in 1805, and with the subscriptions solicited, in May of the next year a small room was obtained in a house in Bancker Street (now Madison), where forty-two children were instructed. The success of this was such that the next year the Legislature appropriated four thousand dollars towards the erection of a building, and one thousand dollars per annum toward the expenses of the school.

The Corporation also gave them the use of a small building on Chambers Street, exacting the condition, however, that fifty children from the almshouse should be received into the school. The new quarters immediately became overcrowded, as there were accommodations for only two hundred and fifty children.

The following year the City Fathers presented to the city the part of the Commons facing Chatham Street upon which the State Arsenal stood, provision again being requested for the children of the Alms

House. One thousand five hundred dollars was also contributed toward the erection of a new building. Upon this site the first Public School was erected in

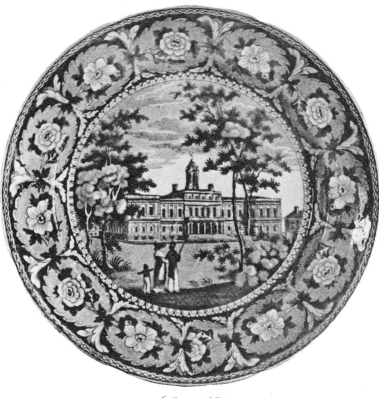

City Hall.

New York the next year at a cost of thirteen thousand dollars, which amount was largely raised by subscriptions from all classes. Many of those unable to con-

tribute pecuniary assistance, gave their labor ; materials were donated by various members of the building trade, and the building operations were conducted by master builders and carpenters who gave their services.

The dimensions of the building were one hundred and twenty feet by fifty. The upper story consisted of one immense room affording accommodations for five hundred children. The lower story was used for the residence of the teacher's family, trustees' room, and smaller school rooms.

The opening of Centre Street in 1837 necessitated the destruction of this first edifice erected for a public school. The view on the plate just described was taken by the decorator from a large lithograph entitled, "City Hall Park in 1824." The original sketch was undoubtedly made before that date, as the fence shown in the illustration is evidently the wooden picket one which was removed in 1821.

South of these historic buildings the corner-stone of the present City Hall, which is shown in the accompanying illustration, was laid in 1803. The total cost of the erection of this splendid edifice was five hundred thousand dollars. The architect, McComb, was retained at a salary of six dollars a day to supervise the building.

It was first occupied by the Mayor in 1811, although

it was not till 1814 that the edifice was completed. The white marble used in its construction was taken from the quarries of Stockbridge, Mass. The original plans demanded that this material should be used for all the exterior walls. Tradition says that from motives of economy the rear end was constructed of red sandstone, as the appearance of this side was a matter of indifference, for the possibility of the city growing beyond it seemed exceedingly remote.

It is not surprising that this building should have been used by four different Staffordshire potters for the decoration of their ware.

For many years it was undoubtedly the handsomest public building of the country, and was regarded by citizens of New York with great civic pride.

John Adams Bowl.

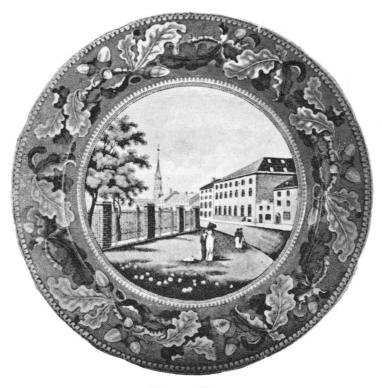

Park Theatre.

PARK THEATRE

To the east of the Commons, fronting the old Boston Post Road, stood the famous Park Theatre, which for half a century was the centre of dramatic life in New York. In 1795 the growing population seemed to warrant the managers of the old John Street Theatre in securing larger quarters for their company. To the Messrs. Mangin, architects and

53

builders, was intrusted the erection of the new building on the site No. 21 Chatham Street (now Park Row). The funds were supplied by a number of gentlemen who thought the undertaking might prove a profitable investment. The building was expensive for the period, costing its owners some one hundred and seventy-nine thousand dollars.

The theatre held its first performance on the 29th of January, 1798. It cannot be said that its financial success was instantaneous. A large part of the better element of the city were still educated to consider the theatre as a place to be shunned, and actors as boon companions of his Satanic Majesty. The lot of the managers of this new undertaking was not a happy one, and constant changes took place in its management. The old corner-stone bears the names of Lewis Hallam and John Hodgkinson as managers. By the time the building was completed the former had been succeeded by William Dunlap, who almost immediately obtained full control owing to the withdrawal of Hodgkinson. Dunlap was also forced to retire, for the enterprise bankrupted him in turn. In 1805 a company of actors attempted to run the theatre on the coöperative plan, but they were also obliged to leave the field. Five years later a new management took possession, and securing the great George Frederick Cooke

from London as an attraction, soon secured a substantial patronage, which assured the success of the theatre for nearly forty years.

In 1820 the interior of the original theatre was completely burned out. It was almost immediately rebuilt by the owners, Messrs. Beekman and Astor, who had purchased it early in the century from its original owners for fifty thousand dollars, and reopened it the following year. The building as seen in the illustration was of the plainest possible description, yet it answered the purposes for which it was erected.

The edifice was eighty feet in length, one hundred and sixty-five feet in depth, and fifty-five feet high. It was constructed of brick covered with an oil cement, which gave it the appearance of the brown free-stone so largely used for building purposes. The interior contained a commodious pit, three tiers each of fourteen boxes, and a gallery. On the second floor, with the windows opening on the street, was a nicely furnished coffee room, fifty feet long, where refreshments were furnished for both sexes ; a similar room on the story above, known as the "punch room," enabled the gentlemen of the audience to quench their thirst without leaving the building.

The hours when the play began varied from 6.30 P. M. in the winter to 7.30 P. M. in the summer. Cer-

tainly no theatre in this country has held upon its stage such a number of persons famous in dramatic history, the managers of the theatre, Messrs. Price and Simpson, being untiring in their efforts to satisfy their patrons. Among those who appeared here we find the names of Edmund Kean, Mathews and Macready. John Howard Payne, the "American Roscius," made his début here in 1807, when sixteen years of age, and won the title of the "first American Hamlet" in the following year. Junius Brutus Booth and the elder Wallack were frequently seen upon its boards, and Joseph Jefferson, at the age of four, took part in a fencing contest.

Here it was that in 1823 was first heard in this country the beautiful domestic drama, "Clari, or the Maid of Milan," in which was sung the ballad, "Home, Sweet Home," which made its author, John Howard Payne, immortal. The Italian opera was first given in America on this stage two years later, and literally carried the town by storm. This venerable building was for the second time attacked by fire in 1849 and was burned to the ground.

In the background of the same view is to be seen the old Brick Church, or "meeting house," as for many years it was called. It was erected in 1767 as an offshoot of the First Presbyterian Church in Wall Street; for a long time the two congregations were under the

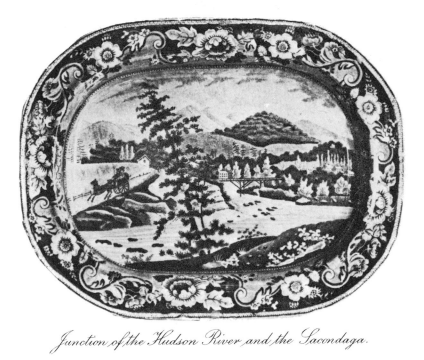

Junction of the Hudson River and the Sacondaga.

same session. The ground on which it stood was part
of the Commons, and was donated by the City Cor-
poration ; the funds were raised by the personal solici-
tation of the pastor, the Rev. John Rodgers, D.D., who
for half a century was one of New York's foremost
citizens.

While a youth, Dr. Rodgers was converted to the
ministry by the preaching of Whitefield during the
great revival of 1748. In 1765 he was called to New
York, and immediately took a prominent part in the

vital questions of the day. In 1768 he received his degree of Doctor of Divinity from the University of Edinburgh, at the suggestion of Whitefield and through the agency of Franklin, and he entertained Witherspoon, with whom he had long corresponded, on his arrival in New York on his way to become President of Princeton College.

Imbued with the same ideas of liberty and right, these two men in their respective pulpits largely directed public opinion, and it was principally due to the efforts of Dr. Rodgers that the congregations of the two allied Presbyterian churches almost unanimously espoused the cause of the rebels.

In the year 1770 Dr. Rodgers commenced his contributions to the "American Whig." Three years later he is found among the visitors to the imprisoned McDougal, and with his colleague, Mr. Treat, contributed "forty-five" pounds of candles to the entertainment of the incarcerated patriot. He was as bold as he was earnest. At the time of the invasion of Canada, in 1775, while New York City and State were still under the control of the Crown, from his pulpit and in the presence of Royal officials he offered strenuous prayers "for the success of the arms of those who were fighting for the liberties and privileges of the Colonies and exposing their lives in defence of the natural rights of

mankind." The same year he waited upon Samuel Adams and John Hancock while they were passing through the city on the way to the Continental Congress, and publicly congratulated them upon their escape from the forces of General Gage. After the capture of New York he was appointed, in April, 1776, Chaplain to General Heath's brigade, which position, however, he held but a short time.

The greatest service that Dr. Rodgers rendered during the war was his secret mission to the " Regulators " of the Carolinas. These stalwart farmers and herdsmen of Scotch-Irish descent, who had long been living in the upper counties of the Carolinas, had banded themselves together for mutual protection against horse-thieves and depredators of all classes. In 1771, goaded beyond endurance, they most forcibly resented the excessive taxes and fees imposed by the officers of the Crown, and arose in rebellion. A severe battle was fought between them and the Royal army, in which the " Regulators " lost nearly one hundred of their number, killed and wounded. The remainder surrendered ; six of their ringleaders were hanged and the rest pardoned upon taking the oath of allegiance to the King.

The attitude of these people at the outset of the war worried Congress not a little. These staunch Presbyterians, whose whole soul was with the cause of

liberty, steadily refused to volunteer their much needed services, holding with Calvinistic tenacity that having recently taken the oath of allegiance they must not oppose their sovereign no matter under what provocation. To these men Dr. Rodgers was sent by Congress. He chose a kindred spirit as companion, James Caldwell, the pastor of the First Presbyterian Church of Elizabeth, N. J.; and during the heat of summer these two clergymen traveled on horseback some six hundred miles to North Carolina. Even their eloquence and fervor seemed unavailing at first; but the persistent efforts of their logic proved to the sturdy Covenanters that by the broken faith of his Majesty George III, they had been absolved from their oath, and the Continental army received the much needed recruits from the famous Carolina riflemen, whose deadly marksmanship helped win many battles.

After the capture of New York by the Royal forces the church was used for a hospital, and not till 1787 was it repaired and restored to its original uses. The energies of its pastor were still unabated. He founded the Humane Society mentioned in the previous chapter.

In 1787 Dr. Rodgers was made the Vice Chancellor of the recently founded University of the State of New York, and in 1796 became the first president of the Missionary Society, whose efforts were directed toward

spreading the gospel among the Indians. Although he was a man of profound thought and great intensity of purpose, he did not neglect the social side of life, and his presence graced many a noteworthy festive occasion. In 1810, the year before his death, he resigned his charge owing to his advanced years, and was succeeded by the Rev. Gardiner Spring, who occupied this pulpit for nearly fifty years.

In 1856 the changed character of the lower part of the city necessitated the removal of the congregation to their present home, the Brick Church on Murray Hill.

In the illustration on page 53 is also to be seen a large building adjoining the theatre. This was a popular tavern much frequented by the farmers and drovers who entered New York by the old Boston Post Road.

The dwelling just this side of the church, No. 32 Park Row, was the residence of John G. Leake from 1806 to the time of his death in 1827. This Mr. Leake, the son of a British officer who settled in New York after taking part in the disastrous Braddock expedition, was a well-known lawyer of great ability and wealth. The last of his race in this country and proud of his lineage, with a view of perpetuating his name, he willed his entire property to Robert, the son of his intimate friend John Watts, upon condition that the recipient should adopt the name of Leake. In event of the

failure of young Watts to agree to the stipulation, the fortune was to be used in founding an Orphans' Home. No sooner had an act of Legislature been secured, enabling the young man to fulfill the conditions of the gift, than young Watts sickened and died, and the immense Leake fortune came into the hands of John Watts. This, gentleman immediately devoted it to his dead friend's wish, and the great Leake and Watts Orphans' Home was founded.

Next to Mr. Leake's house was the residence of Philip Rhinelander.

Just beyond the Brick Church, in the building now occupied by the New York "Sun," was the home of the Tammany Society, which was founded in 1791 as an offset to the so-called aristocratic tendencies of the Order of the Cincinnati. While it started ostensibly as a benevolent society, its purpose soon became well understood and caused the following comment from the Rev. Timothy Dwight on his visit to the city in 1811 : "The Tammany Society, or Columbian Order, confessedly established to afford relief to persons in distress. Their principal business, however, is believed to be that of influencing elections."

Much of the view on the plate just described is taken up by the unsightly iron fence, with its tall stone posts, which surrounded the City Hall Park. These

railings were imported in 1821 from England, as our infant industries at that time were not equal to their manufacture.

The date of the making of this plate is partly established by the fact that the view upon its surface is an exact reproduction of a print which appeared in Goodrich's " Picture of New York," published in 1828.

Charleston Exchange.

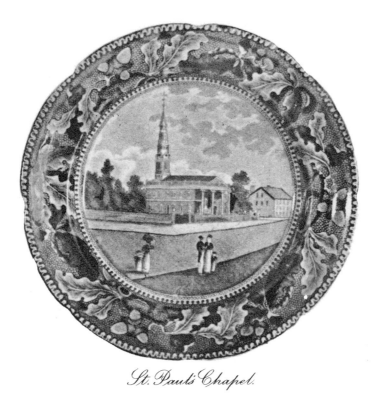

St. Paul's Chapel.

ST. PAUL'S CHAPEL AND CITY HOTEL

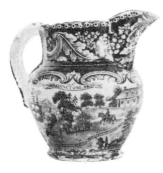

OUT of town, among the fields, in 1764, was laid the corner-stone of St. Paul's Chapel, which the plate at the head of this chapter pictures. Just why this locality was chosen we do not know, and numerous comments were made upon "the folly," as it was termed, of erecting a church so far away from the residences of the worshippers. The

building faced the Hudson River, and the churchyard sloped down to what is now Greenwich Street, which then marked the river bank.

Two years later it was opened for service; the dedication was made a state ceremony. The clergy in their sacramental robes awaited the Governor at Fort George. The procession that marched up Broadway was indeed stately. It consisted of the Mayor and the City Fathers, the Governor, Sir Henry Moore and staff, and the Governor's band of " Musik," which took part in the service upon the Governor's orders, notwithstanding the protests of the vestry. A vast concourse of people followed the clergy and dignitaries in full regalia. The sermon was preached by the Rev. Samuel Auchmuty, D.D., who was described as " Rector of Trinity Church, and Chaplain to the Right Honorable William, Earl of Stirling."

Upon the occupation of the city by the Continental troops, the regular services of the Church of England were continued in the various English churches; and though much indignation was aroused by the use of the prayer for the King as contained in the ritual, there was no open interference with the divine services. After the Declaration of Independence, however, prudence caused the Rector of Trinity, the Rev. Dr. Auchmuty, to close the churches of the parish, public senti-

ment having reached such a stage that a prayer for the King would not have been longer tolerated. To the credit of the American commanders it should be stated that these buildings remained unused, in striking contrast to the treatment by the British of the property of the Presbyterians. Upon the evacuation of New York by the American forces the church was reopened for regular services. At the close of the war the leaders of the Church of England, forgetting the bitter animosities so long waged between the two church factions, most magnanimously offered St. Paul's Chapel for Sunday services to the two Presbyterian congregations, rendered homeless by the ruined condition of their edifices.

In 1789 another momentous procession marched up Broadway to the Chapel from Federal Hall, in Wall Street, where Washington has just been inaugurated President of the United States. Escorted by gaily equipped troops, both horse and foot, walked the illustrious Washington, Vice-President John Adams, the foreign ministers, both houses of Congress and a vast number of officers and soldiers, by whose energies the Royal yoke had been thrown off, and statesmen whose intellectual efforts had led to the adoption of the Constitution. Divine service was conducted by Bishop Provost, Chaplain to Congress and one of the few cler-

gymen of the Church of England who had preferred liberty to Royal domination. The choice of St. Paul's

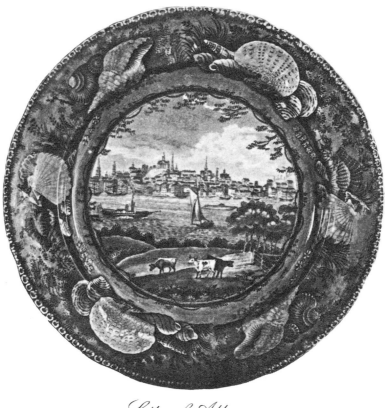

City of Albany.

for this noteworthy occasion was undoubtedly due to the fact that the new President was a vestryman of the Church of England. His diary records that he

attended morning service there with great regularity for the next two years, sitting in the President's pew on the north side of the building. A corresponding pew on the south side was reserved for the Governor.

On the Fourth of July of the same year the great Alexander Hamilton delivered from its pulpit an oration upon Nathanael Greene before the members of the Order of the Cincinnati.

The appearance of the Chapel was greatly improved by the addition of the spire in 1794.

In 1818 the remains of the gallant Montgomery were brought from Quebec, where they had rested for almost forty-three years, and interred beneath the mural monument under the chancel window. This monument was erected by the city in 1777, in accordance with an act of Congress passed almost immediately upon the news of the death of the hero. It was selected in France by Benjamin Franklin.

St. Paul's is now the only sacred edifice in the city which stands as a silent witness to the early days of the Republic.

The house to the right of the Chapel has an interesting history also. Before the Revolution Broadway only extended as far uptown as St. Paul's Chapel; the continuation upon which this house stood was known

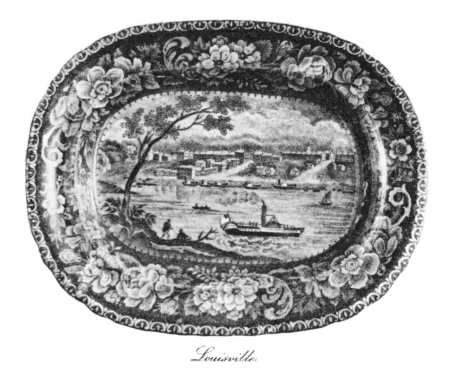

Louisville.

as Great George Street, and was little used.　All traffic
turned off to the Boston Post Road.　This house, built
about 1770, was the home of Major Walter Rutherfurd,
a Scotchman, who, retiring from the English army,
settled in New York.　He married Catherine Alexander,
the sister of Lord Stirling.　While his sympathies were
with those engaged in the struggle for Independence,
he did not feel able to take up arms against the colors
he had fought under for so many years.　Upon the re-

treat of the Continentals from the city he removed to
New Jersey, where he made his home among those
high in the councils of the cause of Congress, to whom
his loyalty was undoubted, though questioned at first.

At the end of the war Major Rutherfurd returned
to his New York residence, where for many years he
lavishly entertained the prominent people of the period.
After his death in 1803 the house came into the posses-
sion of his son, John, who for some years represented
New Jersey in the Senate. The latter was also a lead-
ing member of the Commission appointed by an act of
the Legislature in 1807 to lay out the streets in the
upper part of the city. The plan of these Commission-
ers has been adhered to up to the present time.

In 1808 the house was remodeled. It gradually
lost its character as a residence and at a later period be-
came a store. Finally it was pulled down by John
Jacob Astor to make way for his famous hotel.

In no part of the city have greater changes been
wrought than in New York's great thoroughfare,
Broadway.

The above illustration shows us the Broadway of
seventy years ago, the large building in the centre be-
ing the City Hotel, situated on the block between
Thames and Cedar Streets (115 Broadway). In the
foreground is to be seen a characteristic picture of every-

day life. Coal had not yet come to be looked on with favor, so the inhabitants relied almost entirely upon wood for their fuel. The sale of this was controlled by a law which provided that wood could be sold only on the wharves by the cart load, and when dumped in front of the purchaser's residence it had to be immediately sawed into convenient lengths and stored away. This work was usually done by negroes, who with sawhorse and saw followed the wagon loads from the river front.

On the opposite side of the street appears one of the old-fashioned pumps, which were sunk by the Corporation into the sidewalks at intervals of a few blocks. Strange as it may seem, these pumps were practically the sole source of water supply to the residents until the introduction of the Croton water in 1842. The water supplied by the Manhattan Company through its filthy wooden pipes was almost undrinkable. Those who could afford it obtained water for drinking purposes from men and boys who hawked it through the streets in wagons. This water was mostly obtained from the famous Tea Water Pump on the corner of Roosevelt and Chatham Streets, and was sold for two cents a pailful.

The deserted character of the roadway can be ascribed to the fact that there were few private car-

riages, and stage lines to the adjoining districts were not numerous. The principal means of locomotion for those whose vocation called them out of doors was the

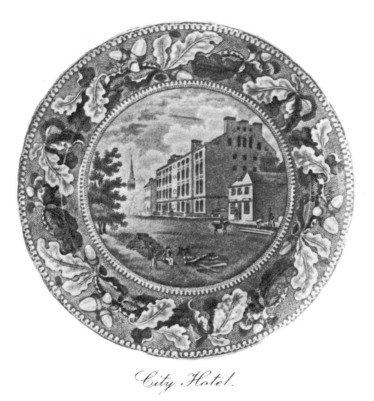

City Hotel.

horse, as seen in the picture. Driving for pleasure in the city was interfered with by the dirty and dusty condition of the streets, for as there was no sewerage system in use, the refuse from the houses was emptied

73

into the centre of the street, whence it was removed at irregular intervals. The best scavengers, however, were the hogs which were turned loose in the thoroughfares to seek subsistence. As late as 1825 it was estimated that there were twenty thousand hogs feeding in the streets. When municipal pride attempted to enforce a regulation to confine them within certain limits, a terrible yellow fever epidemic due to the filthy condition of the city soon changed public sentiment, and the hogs were allowed their old privilege of roaming at will.

The City Hotel, the principal building in the picture, stood on the site of the old City Tavern, which was pulled down to make room for its famous successor by the Tontine Association which purchased the property from Peter Delancey. Its foundations were laid in 1794, and four years were occupied in the completion of the work. It was built by Ezra Weeks. The City Hotel was four stories in height, and for many years overtopped the surrounding buildings and was easily distinguished from the neighboring shores of New Jersey and Brooklyn.

This building was the first one in New York which had a slate roof. That quaint character, Grant Thorburn, the seedsman, the "Laurie Todd" of literature, relates in his reminiscences that when the roof was

about to be laid, no nail-maker could be found to make the peculiar nails needed for fastening down the slates. Inquiries being made among the emigrants upon the vessels just arrived in the harbor, he, having served an apprenticeship at this work at home, volunteered for the job, and soon supplied what was necessary for the completion of the roof.

Many pleasant memories are associated with this famous hostelry. In its assembly rooms the musical societies gave their concerts, and the bar and offices served as a rendezvous for those kindred spirits who at the present time throng our political and social clubs. In the ladies' dining-room, on the second floor, the noted dancing master, John Charruaud, taught the young people the latest steps and served as floor manager for the sociables arranged by those of more mature years.

The dining-room was the scene of many a famous dinner, the most noteworthy of which was that given by the citizens to the officers of the "Constitution" and "United States," in honor of the closely consecutive victories of these vessels and the "Wasp" over the "Guerrière," "Macedonian" and "Frolic." These triumphs, coming so soon after the disgraceful defeats in Canada, were made the occasion for wild demonstrations of joy throughout the country.

The "Guerrière" had been especially obnoxious to the New Yorkers. The name "Robber Ship," applied

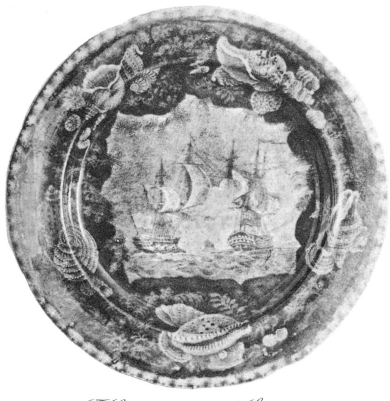

The Constitution and the Guerrière.

to her in this vicinity, was well deserved from her actions while stationed off the Long Island coast, and her capture by the "Constitution," the idol of the American

navy, was undoubtedly the most popular naval event of the war. It can be readily conceived that plates picturing this naval engagement must have had a

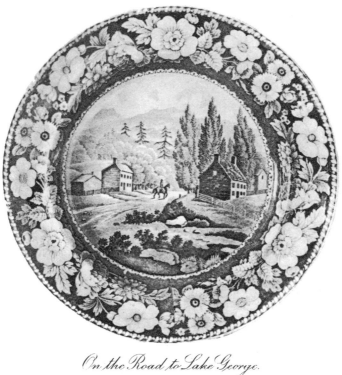

On the Road to Lake George.

ready sale among people proud of the achievements of their little navy.

At the banquet referred to five hundred gentlemen sat down in a room lavishly adorned with appropriate

decorations ; De Witt Clinton presided. On his right was seated Commodore Hull, and on his left the gallant Decatur. Ten days later the "United States" brought her prize into port, and another dinner was provided for her four hundred sailors in the dining-room in which the identical decorations used at the banquet given to the officers were retained for this occasion. The "jackies" were afterwards taken to the Park Theatre, where a performance was arranged for them.

Travelers from foreign lands bore testimony to the excellence of this hostelry. One wrote of it in 1824 as follows : " I find the building extensive ; quite equal to a first-rate European hotel in size, excelling the latter in some conveniences and inferior to it in others. It is clean from top to bottom, carpeted in almost every room. . . . Our own accommodations are excellent. They comprise our bedrooms, which are lofty, airy, and convenient, and a *salon*, which would be esteemed handsome even in Paris. . . . The master of the house is a respectable and an exceedingly well-behaved and obliging man, who of course, allows each of his guests, except those, who voluntarily choose to live at his table d'hôte, to adopt his own hours, without a murmur, or even discontented look." In 1827 the terms were $1.50 per day, $10 per week, and $416 per year—a good illustration of the moderation of the times. In 1828

the property changed hands, the purchase price being $123,000, and in 1850, having outlived its usefulness, it was pulled down.

The buildings adjoining the City Hotel were used as stores. This part of Broadway was, for many years, largely occupied by book stores and lotteries. The latter were well established and patronized, occupying a position in the community analogous to the Exchanges of to-day, for the speculative spirit, born in all Americans, was as rampant then as now.

Commenting upon those institutions, regularly licensed by the mayor and whose drawings in many cases took place upon the steps of the City Hall, a writer of the day says that the total sale of tickets " dosed out " amounted to $2,543,976, during the eleven months from May, 1827, to April, 1828.

An editorial from the staid " Evening Post " of the 14th of October, 1828, reads as follows : " It has been customary to remind our readers the day before a drawing of a lottery takes place in the city that such an event is about to take place, so that those who have procrastinated their contemplated purchase of a chance may be reminded that the time is fast approaching when it will be too late to correct their errors. Such will be the case to-morrow at 4 P. M." Such was the importance given to the lottery.

Just beyond the Hotel is to be seen Trinity Church, not, however, the second Trinity Church, which had been destroyed by the great fire of 1776, and not the Trinity of to-day ; but the third Trinity, built upon the ruins of its predecessor in 1788, which, in turn, was superseded in 1837 by a structure more in keeping with the requirements of the enlarged city. An original sketch made by one of our local artists, undoubtedly C. Burton from its general characteristics, supplied the maker Stevenson with the subject for the decoration of this plate. The plate showing a view of St. Paul's probably had the same history.

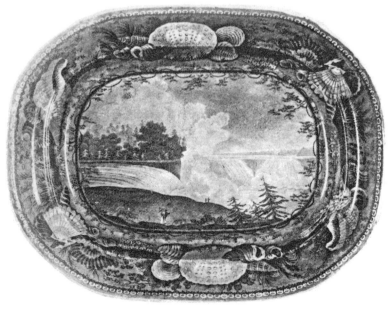

Niagara Falls.

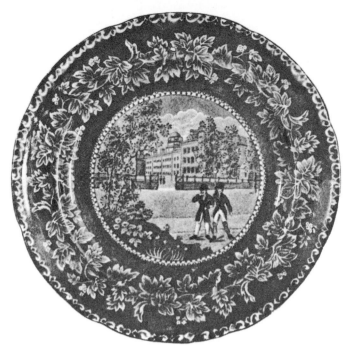

Columbia College.

COLUMBIA COLLEGE
DOCTOR MASON'S CHURCH AND
SAINT PATRICK'S CATHEDRAL

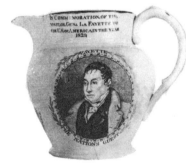

To the west of Broadway, on a plot bounded by Murray, Church, Barclay and Chapel Streets, the cornerstone of King's College was laid on August 23rd, 1756. Two years before this date the charter had been obtained after a long and bitter controversy between the leaders of the Church of Eng-

land and the Presbyterians. About the time of the erection of the building an English traveler described it as "pleasantly situated near the city of New York, on the bank of Hudson's River."

In 1763 the Rev. Miles Cooper was chosen its second President, and coming fresh from England espoused the cause of the King. He took such an important part in the literary contests of the day that the college became known as a hot-bed of Toryism. Finally the general indignation aroused by the active stand he took against the Sons of Liberty was so intense that on the evening of May 10th, 1775, a mob broke into the college grounds with a purpose that boded no good to the reverend Oxonian. Forewarned by a student, he escaped to the shore, and, after spending the night upon the beach, the next morning took refuge on the British sloop-of-war " Kingfisher," which carried him to England, where he was warmly welcomed and presented with two handsome livings. He died a few years afterwards, and at the sale of his effects his library fetched five pounds and his liquors one hundred and fifty guineas—a most curious comment upon the outfit of a college president and curate of the day.

In the spring of 1776 the Committee of Safety ordered the College to be prepared for the use of troops, and throughout the war this building served as a hos-

pital. At the close of the Revolution the main provisions of the charter were confirmed by the Legislature. The complexion of the Board of Trustees was changed, and the name was altered to that of Columbia. The first student who entered at the reopening was De Witt Clinton.

In 1814 the Legislature purchased the Hosack Botanical Garden, a tract of twenty acres lying between Fifth and Sixth Avenues and Forty-seventh and Forty-ninth Streets, and presented it to the College as a compensation for lands previously granted, and which, after a bitter controversy, were acknowledged to belong to the State of Vermont. This land, for many years unproductive of revenue, has been retained and forms the principal part of the endowment of Columbia University.

The belfry was added in 1820, and the building was enlarged by the addition of two wings, and the surface was covered with brown stucco. The spacious grounds, adorned with beautiful trees and surrounded by a stone wall surmounted by an iron railing, made this a favorite part of the city for residences.

In 1825 the College was in a flourishing condition. The faculty consisted of a president and five professors, and the students numbered about one hundred and thirty. Requirements for entrance in the classics were

not far different from those exacted to-day, but were woefully lax in other branches of study. The "candidate" was only asked "to be well versed in the first four rules of arithmetic, the rule of three direct and in-

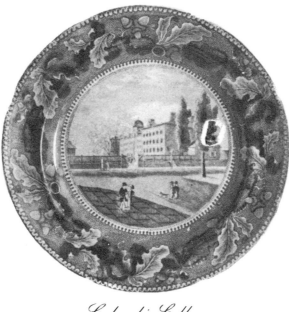

Columbia College.

verse, decimal and vulgar fractions, with algebra as far as the end of simple equations."

The three plates shown in the illustrations are all the work of Stevenson. They may well be taken as examples of the rapid advance in the maker's art. The

poorly printed view with the vine-leaf border was quickly followed by the artistic picture with its border of oak leaves and acorns. This, in turn, was superseded by the design encircled by a border in which

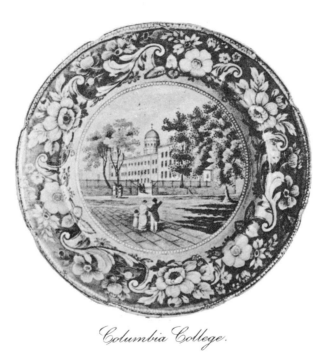

Columbia College.

roses and scrolls are intermingled. It is very evident, from the varying amount of foliage, that the sketches for these three views were made at different seasons of the year. The varieties of the trees in the foreground stamp these views as the work of various artists who

85

with artist's license introduced foliage to suit their own ideas of the beautiful. The Lombardy poplars are inseparably associated with the memory of André Michaux, who was sent to this country in 1791 by Louis XVI from the Jardin des Plants, Paris. He introduced these trees into New York.

Facing Columbia College on Murray Street, in 1812 was erected the church which, from the extreme popularity of its pastor, was generally known as Dr. Mason's Church. The principal funds for building this church were provided by a wealthy Scotchman, William Wilson, who, arriving in New York shortly after the Revolution, became an importer of dry goods. This gentleman not only amassed a fortune in his trade, but by means of his public spirit acquired a respected position in the community. The edifice was of red sandstone. Its dimensions were ninety-two feet in length by seventy-seven feet in depth. Pilasters decorated the front. The church was surmounted by a steeple about two hundred feet high. Adjoining the church was the residence of the pastor.

For many years Dr. John M. Mason, son of the famous Dr. John Mason, was one of New York's most distinguished citizens. He was one of the founders of the New York Historical Society, and like the great Doctor Rodgers, mentioned in a previous chapter, took

a prominent part in the vital questions of the day. An intimate friend of Alexander Hamilton, he attended this statesman upon his deathbed, and was chosen by the Society of the Cincinnati to deliver before their

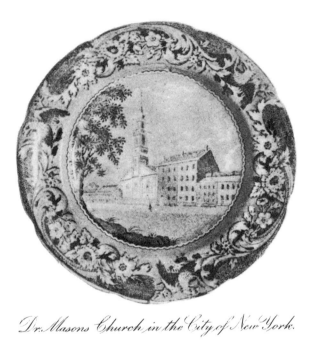

Dr. Masons Church in the City of New York.

members an oration upon this great patriot and financier.

In 1804, with the view of enabling those preparing for the Presbyterian ministry to complete their studies at home instead of in Scotland, he founded a Theologi-

cal Seminary in this city, and going abroad for the purpose, collected some three thousand volumes for the foundation of its library. Two years later he established the "Christian's Magazine," and in 1811 became Provost of Columbia College.

The capacity of this wonderful man for work seemed boundless. In addition to the duties of pastor of a large congregation from 1811 to 1817, he spent five mornings a week at the College, where he lectured on the Evidences of Christianity. His afternoons were devoted to the Theological Seminary, in which he held a professor's chair; at the same time he edited the magazine alluded to. It is not surprising that six years of this work undermined his constitution, and he left the city to become President of Dickinson College. Dr. Mason was unequaled as a pulpit orator, and his reputation was world-wide.

The Third Associate Reformed Church, or Dr. Mason's Church as it was popularly called, consisted principally of persons who had belonged to the Scotch Presbyterian Church in Cedar Street while Dr. John M. Mason was minister there, and who left with him in 1810 when he resigned the pastorship of that church. The church was pulled down in 1842. Each stone was carefully marked, and the building was re-erected in Eighth Street. An original drawing supplied Joseph

Stubbs with the subject for this poorly printed plate shown on page 87.

Upon a sauce-boat appears a picture of St. Patrick's Cathedral in Mott Street. The Cathedral was consecrated in 1815. It was the largest building erected by any religious denomination in the city. The architecture was Gothic. The structure was one hundred and twenty feet long by eighty feet in depth, and its walls were nearly seventy feet high. The roof rose at a sharp angle to a height of nearly one hundred feet, and its tower was easily distinguished from the water. Its front walls on Mott Street were of hewn brown stone, and in them were left several niches for statues. Its organ was renowned as well as its choir. An engraving by A. J. Davis, published in the New York " Mirror " in 1829, furnished Stevenson with this view.

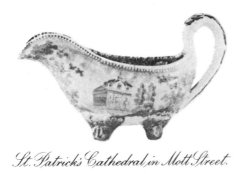

St. Patrick's Cathedral in Mott Street.

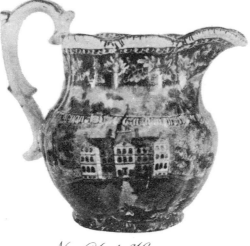

New York Hospital.

NEW YORK HOSPITAL, INSANE ASYLUM AND ALMS HOUSE

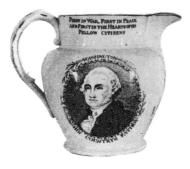

THE corner-stone of the New York Hospital was laid on July 27th, 1773, by Governor Dunmore. To Dr. Samuel Bard and Dr. Samuel Jones belong the credit of exciting interest in this undertaking.

At the commencement exercises of King's College in 1769 the former made the first public plea for a building where the indigent sick and suffering could receive proper attention, and at the suggestion of the Governor of the Province a subscription list was then and there

opened. Two years later a charter was granted. In 1773 the collection of funds had progressed so far that it was deemed safe to start to erect the building. Five acres of land were secured three-quarters of a mile from the town. The plot on which this building stood is now bounded by Broadway, Worth, Church, and Duane Streets. While approaching completion the building was most unfortunately attacked by fire in 1775 and badly damaged. However, with the assistance of £4,000 granted by the Assembly, the structure was repaired and finished in 1776. Its first occupants were wounded Continentals.

On July 12th, 1776, while the British ships were sailing up the North River, they were fired upon from the Hospital grounds. The British fire in return was harmless, the only victim being an unfortunate cow. However, owing to careless handling of the artillery, the premature discharge of a cannon killed six and wounded four of the raw Colonial troops.

Upon the capture of the city by the British the building was taken possession of by the Hessians, and was used as a barrack throughout the war. After the evacuation of the city by the Royal troops, the poverty-stricken condition of the citizens prevented funds being raised to properly equip the building for its original purposes. It was first opened for the reception of

patients in 1791, though for several years it had been used by the medical fraternity of the city in various ways.

In 1788 it was the scene of the so-called "Doctors' Mob," which for a few days kept the city in an uproar. The feeling against dissection, so prevalent at the time, was intensified by the fact that for some time past there had been considerable rifling of the graves by medical students, not only in the Potter's Field and Negroes' Burying Ground, but also in private cemeteries. Tradition tells us this was fanned into a flame one day when some boys playing in the Hospital grounds saw hanging out of one of the windows an arm and a leg which some medical student had most thoughtlessly exposed. One of the boys declared that they belonged to a relative of his who had recently died. How he recognized them he did not state, but running in terror from the yard he related what he had seen. An immense mob quickly gathered, and hurrying to wreak their vengeance upon the offending doctors, pushed in the doors, destroyed the anatomical collection, and finding fresh bodies in the dissecting-room, bore them off in triumphant procession, for interment. The next morning the city was in a tumult. Not satisfied with their work of the previous day the mob proceeded to search the houses of the suspected physicians, and it was only

owing to the strenuous efforts of Clinton, Hamilton and Jay that they were dispersed.

The students and doctors were sent to the jail for safe-keeping, but the popular excitement was too intense for the matter to be dropped immediately. An immense crowd of people surrounded the jail in the afternoon and demanded their prey. To have given them up meant certain death. The militia was ordered out and defended the jail against great odds. The temporary rebuff only served to inflame the mob, which tore down the jail fence and broke the windows of the building, shouting death to all the members of the medical profession in the city. Towards evening the number of besiegers had so greatly increased that the Mayor, James Duane, aroused a number of the best and most respected citizens, and went to the assistance of the militia. John Jay attempted to pacify the rioters, and only desisted after he was struck in the head with a stone. The Mayor determined upon summary measures, and ordered the militia to get ready to fire. Baron Steuben begged him to wait a little, but while he was pleading a brick flew through the air and toppled him over. The Baron immediately saw the matter in a different light, and as he was falling shouted, " Fire, Mayor, fire ! " This order was given, and at the first volley thirteen persons fell, five of whom were mortally

wounded. The remainder experienced a change of heart and went to their homes. Thus ended the famous "Doctors' Mob," though the militia guarded the medical profession in the jail for some days afterwards.

In 1791 the Hospital was fully repaired, and until its removal in 1868 it was the centre of medical life in the city.

The Hospital building, as originally designed, was one hundred and twenty-four feet long, to which were added two wings eighty-six feet in depth. Its gray stone walls were a well-known landmark until the building was pulled down in 1868. The Institution was two hundred feet back from Broadway. Its beautiful lawn was a play-ground and place of recreation for many years, and within these spacious grounds the firemen and other social organizations had their parades and picnics.

The well-known vine-leaf border characterizes the pitcher heading this chapter as the work of Stevenson, who probably secured this view of the Hospital from a print of the building first issued in the " History of the New York Hospital," published in 1811, and again in 1821.

Not till 1808 did New York have a building devoted to the care of the insane ; a small number of these had been taken care of in a section of the Hospital. In

1808 a building for the insane was erected upon the Hospital grounds.* It was, however, soon demonstrated that, owing to the surroundings, the inmates could not receive the care and treatment which they required.

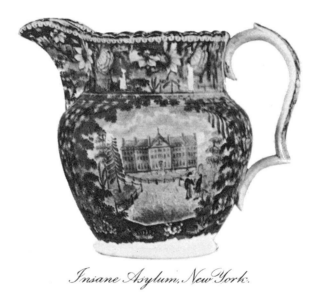

Insane Asylum, New York.

In 1816, upon proper presentation by the Governors of the New York Hospital, an Act of Legislature was procured granting the sum of $10,000 annually, for forty-four years, in support of an institution the need of which was so apparent. Two years later a site was

* This building appears beneath the spout of the New York Hospital pitcher.

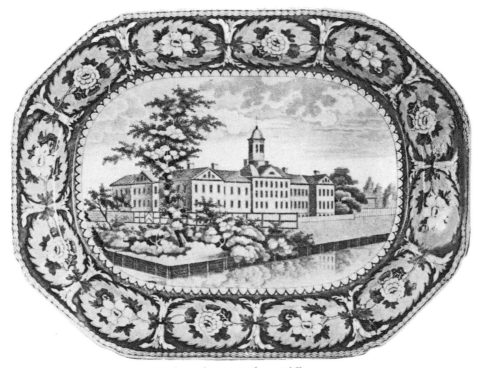

New York Alms House.

selected on the heights of Manhattanville, near the Hudson River, and seventy-seven acres of land were purchased for $500 per acre. A magnificent structure of red sandstone, three stories in height, two hundred and eleven feet in length and sixty feet deep, was built here. This asylum became famous throughout the country, and can be said to have first successfully inaugurated that principle, now so fully carried out, of the treatment of mental diseases. Its superb views and beautifully kept grounds afforded recreation and treatment hitherto impossible. It has long been known as the Bloomingdale Asylum, acquiring this title from the beautiful Bloomingdale Heights upon which it stood. Owing to the growth of the city, this institution was forced to move to White Plains in 1894, and its property was sold. A portion of this is now occupied by the buildings of Columbia University.

A small print, published by Messrs. Rawdon, Clarke & Co., furnished Clews with the view of the New York Insane Asylum for the pitcher reproduced upon page 96.

To the Staffordshire potter we are indebted for another reminder of the great philanthropic institutions of New York—the New York Alms House at Bellevue. The old Alms House on the Commons, described in a former chapter, having become overcrowded, the cor-

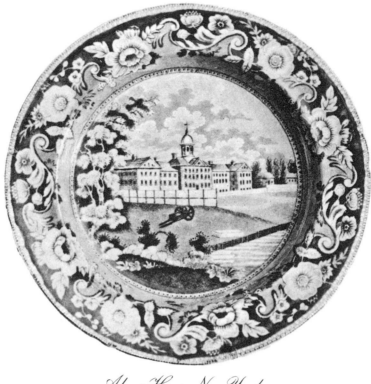

Alms House. New York.

ner-stone of what is now Bellevue Hospital was laid in
1811 ; a plot of six acres of land having been secured
by the city at Twenty-sixth Street and the East River
at a cost of $22,000. The building, opened in 1816,
was enormous for the times, being some three hundred
and twenty-five feet in length, besides having large
wings, and was constructed of stone taken from a neigh-
boring quarry. This also became inadequate to the
increasing needs of the city, and in 1848 its occupants

were transferred to their present quarters on Black-well's Island. A few years later the building was re-modelled, and is now known as Bellevue Hospital.

The platter showing a view of the Alms House was made by Messrs. J. & W. Ridgeway. These gentle-men sent to the American market large dinner sets decorated with numerous views of public buildings. These sets were labelled "The Beauties of America," rather a strange title, for the prevailing decoration on the various dishes are views of hospitals and alms houses.

Mr. Simeon Shaw, in his little volume on the Staffordshire Potters published in 1829, writes of this firm as follows:

"Messrs. J. & W. Ridgeway enjoy justly merited celebrity for their unabating energies to promote the general improvement and welfare of the parish. Pos-sessed of considerable talent, and enjoying a full share of public confidence, they have always been among the most zealous and ardent alleviators of the sufferings of the distressed, and careful guardians of the public or parochial funds. Wishful to ameliorate the condition of mankind at large, they are ever found second to none in liberality and perseverance. And we may add they are a blessing to the neighborhood. Posterity will long hold their memory in grateful admiration."

After reading this description it is possible to understand why the Messrs. Ridgeway considered our hospitals and alms houses the "Beauties of America."

A view of the Alms House taken from a sketch by W. G. Wall was also used by Stevenson in the decoration of dinner plates. The same scene also appears upon the clumsily decorated pitcher here shown.

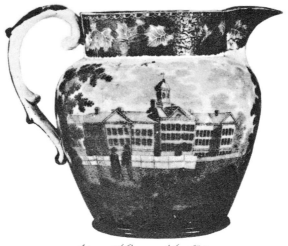

Alms House, New York.

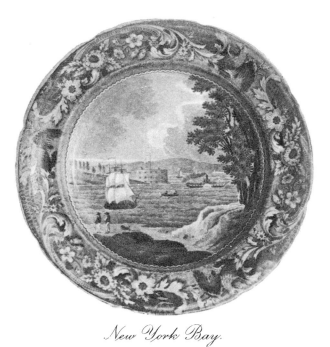

New York Bay.

THE BATTERY

NEW YORK knows no spot so universally secure in the affections of its residents as that which in Knickerbocker parlance was termed "The Battery," "Battery Walk," or "Battery Parade."

From the early days of the stalwart Dutch burghers the people loved to gather on this spot to view the constantly changing beauties of the harbor, and to

enjoy the cool breezes from the ocean. Although sur-
rounded by the residences of the wealthy, the rich
and poor met here on an equality not possible now in
this immense metropolis. In the summer of 1794 one
Joseph Corré, the enterprising owner of a favorite place
of refreshment near the northern end of this delightful
spot, conceived the idea of making the Battery still
more attractive, and petitioned the Corporation for the
privilege of lighting a few lamps and erecting some
benches along the water's edge. After momentous
discussions this petition was refused, the august City
Fathers taking the position that it would not be well to
encourage in any way the absence of young people from
their family firesides after the ringing of the curfew.

In 1805 the Corporation first took steps to improve
this part of the city, and ordered the removal of the
remnants of the batteries which stood along the water's
edge, and placed benches here and there. Permission
was also given for the erection of a temporary shed
from which refreshments were served. This booth was
near the flagstaff at the extreme southeastern portion
of the pleasure-ground. In the same year the Super-
intendent of Repairs was instructed to put the grounds
in good order. These orders were practically the be-
ginning of the park system, which, under city control,
has developed into such tremendous proportions.

In 1809 Joseph McLaughton erected an octagonal two-story wooden building around the same flagstaff at the southeastern extremity of the Battery. Particular emphasis is laid upon the location of this building, as it must not be confounded with the churn-shaped structure put up around another flagstaff upon the western portion of the park, a view of which is shown in Drayton's "Northern and Eastern Tour," published in 1793. It also appears in a lithograph of a drawing by Robertson in the volume published in 1825, illustrating the Grand Canal Celebration. This latter building was pulled down in 1825.

The structure shown in the illustration on the following page was rented to the builder, who was given at the same time the monopoly of the sale of refreshments of various kinds on the public grounds in this vicinity. He undertook in return the entire responsibility of keeping the fences, grass and trees in good condition, and also was pledged to see that this part of the city property under his charge was managed in a manner conducive to good morals. During the war which shortly followed this building came into the control of Messrs. Hathaway and Marsh, and what was popularly known as the "Flagstaff" was the scene of many a merry-making. The alluring advertisements in the daily papers invited the reader to many a concert

given by the various regimental bands. The tickets admitting to the gallery were twenty-five cents, and were sold at the bar, which occupied the lower story.

Particular stress is laid upon the view which Ste-

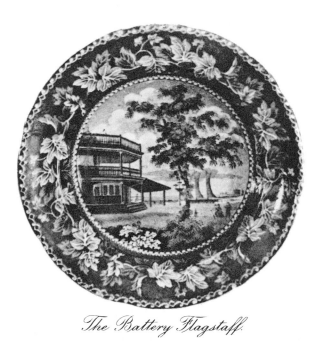

The Battery Flagstaff.

venson, the Staffordshire potter, has given us. Made from an original sketch, it alone preserves to the lovers of New York history a picture of the summer-house around which the out-of-door social life of the city was practically centered until Fort Clinton was turned into

a place of amusement. The five views of the Battery illustrating this chapter were taken from sketches which have been reproduced in no other form. With their rich coloring they give happy and faithful pictures of New York's popular pleasure-ground.

Leaving this building and walking westward, another view (see page 103) which attracted the artist was used by Joseph Stubbs, the potter, who from his wares can be surely classed among those who loved the beauties of nature. Castle Williams, looking just as antiquated as the Castle Williams of to-day, looms up before us ; yet this fortress, in its early history, was once considered well-nigh impregnable. Designed in 1807 by Colonel Jonathan Williams of the United States Engineers, to whom was entrusted the duty of devising a comprehensive plan of fortifications for the defence of the city, the work was finished in the next four years. It was built of Newark sandstone, with walls forty feet high and eight feet thick. The lower tier mounted twenty-seven 35-pounders (English 42's), while on the upper tier thirty-nine 20-pounders glared through the casements, and upon the terrace over the bomb-proof were places for forty-five Columbiads (50-pounders).

In the foreground of this view is to be seen the shore of the East River in all its natural beauty. Two

boys are availing themselves of the play-ground, the favorite place for hunting for the garnets so often found among the rocks in this vicinity. The frigate, with all sails set and her pennant streaming in the wind, as a representative of the little navy, the idol of the people, must surely have added greatly to the popularity of this plate.

Enoch Wood gives a picture of another part of this park upon the large blue platter shown upon the opposite page.

The Battery, as we now know it, is far larger than the enclosure which so delighted our fathers. While in the possession of the British during the War of the Revolution it really boasted of quite a formidable array of guns, which extended along the water's edge from the foot of Greenwich Street to Whitehall Street. These, together with Fort George, were removed about the year 1791. The Battery Park at this time was a slender crescent-shaped bit of ground not half the size of the present area. Only two hundred feet separated the buildings on State Street from the water's edge. This street ended in a little bluff, with a pebbly beach beyond. For the safety of its frequenters a wooden railing ran along the edge of the bluff.

The defenceless condition of the city attracted the attention of the National Government in 1806. A ledge

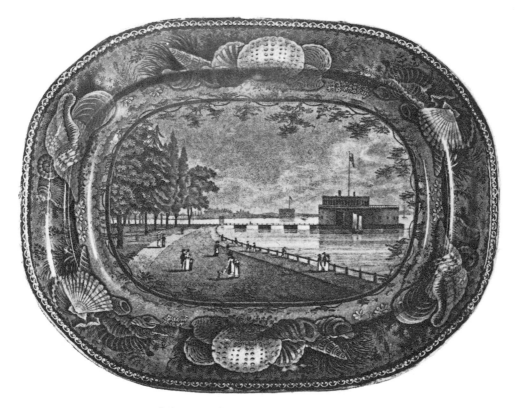

Castle Garden and Battery.

of rocks some three hundred feet from shore was ceded by the city, and in 1807, under the supervision of Lieutenant Joseph G. Totten, was commenced the fortification which was New York's chief bulwark during the war which followed. Completed four years later, it was known as the Southwest Battery. In 1816 the name was changed to Castle Clinton, in honor of the distinguished Governor, George Clinton. Six years later it was dismantled and ceded back to the city, which leased it in May, 1824, for a place of amusement to a Mr. Marsh, the popular proprietor of the "Flagstaff," at a rental of fourteen hundred dollars a year. The name was changed to Castle Garden, and from that time its glories began. Though in 1816 the Battery had been extended seaward, still some two hundred feet of the bridge remained. This became a favorite fishing-ground, and many a fine bass did the piscatorial Knickerbocker land upon the old wooden bridge connecting the fort and the land. Admission to the Garden was secured by ticket, the cost of which was one shilling. This, however, was a merely nominal charge, as the ticket was redeemable at face value in exchange for the various articles of refreshment for sale at the booths in the interior. The top of the old fortification was decked over, affording an extensive promenade, which, plentifully supplied with benches, fur-

nished a delightful escape from the heat of the city. The Castle Band afforded music nightly, and fireworks and balloons were sent off at stated times to the delight of the audience. The impression of this place upon travelers from across the sea was a most pleasing one, and they seldom failed to record the beauties of the scene, the excellence of the entertainment, and the attractiveness of the mint juleps served within.

The same view of Castle Garden appears upon a small plate illustrated on page 103, fashioned to hold the tea and coffee cups after their contents had been emptied into a saucer, from whence, after cooling, the liquid was conveyed to the mouth—a custom which, it is needless to say, has long fallen into disuse.

Another view of this famous building, taken from a different quarter, was used by Stevenson to decorate a large platter; and although it is not so artistic as the one used by Wood, it gives a very realistic picture of life on the Battery Parade. This title may have been applied to the park because the militia was drilled here, but more probably because it was a favorite promenade for the fashionable Knickerbockers of both sexes, who walked up Broadway as far as St. Paul's, and then back again down along the central walk of the Battery.

Certainly a quaint scene is presented on this platter. The picturesque Empire gowns and Leghorn hats of the

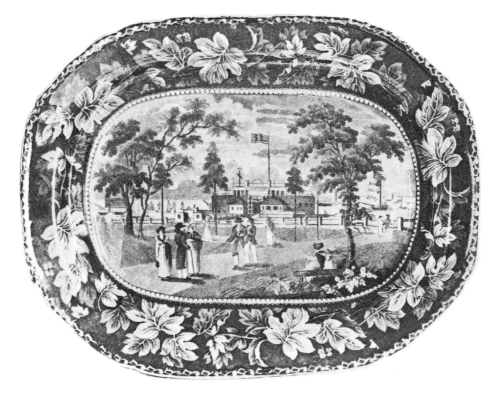

Esplanade and Castle Garden.

fair sex contrast strangely with the long-tailed blue coats and light trousers of the gallants who are most assiduously puffing at the long cigars in vogue at the time. On the water to the left of Castle Garden the artist has pictured the steamboat "Ætna," which was destroyed in 1825 by the explosion of her boilers. To the left, upon the mainsail of a sloop, appear the letters R. S. W. Upon the back of the platter is found the impressed name of Stevenson. This absolutely proves that the plates marked R. S. W. came from the factory of Ralph Stevenson, which proof will be treated in a subsequent chapter. The view used to cover the centre of this platter was undoubtedly the work of C. Burton, and bears a striking resemblance to a print of Castle Garden, though taken from a different quarter, published in the New York "Mirror" in 1830, entitled "New York Battery in 1822."

Stevenson also used an engraved view of Fort Gansevoort, by the same artist, to decorate various plates of a dinner set. This fort, constructed of red sandstone and covered with numerous coats of whitewash (because of which it later became known as the "Old White Fort"), stood near what is now the foot of Gansevoort Street, which site was ceded by the city to the National Government in 1807. Certainly it was not a very formidable object, yet it was supplied with

an oven for heating cannon balls red hot, and it was able to protect New York from an attack of any vessels passing the forts below.

The "Old White Fort" was dismantled after the War of 1812, and its grounds became a favorite place for picnics. The Baptists took advantage of the shelving shore of the river for their immersions.

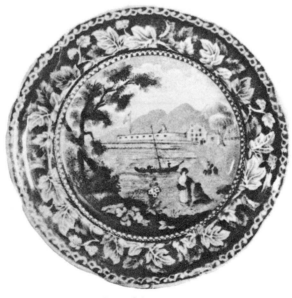

Fort Gansevoort.

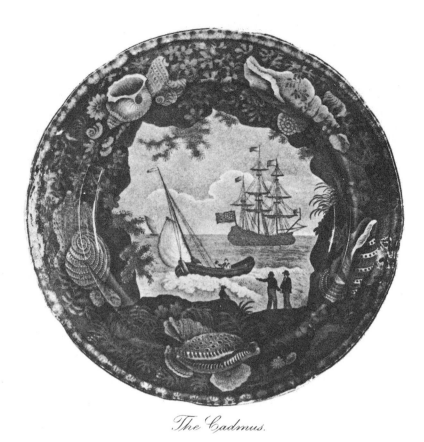

The Cadmus.

LAFAYETTE'S VISIT TO NEW YORK IN 1824

THE visit of General Lafayette to this country, in 1824, made that year memorable. Coming upon a special invitation from Congress and President Monroe, his arrival in New York occasioned a demonstration famous in the annals of the city. This stern old Repub-

lican was little aware of the reception in store for him, as more than forty years had elapsed since he had visited the land whose liberty he had so greatly helped to gain, and he feared that he had been forgotten by the new generation.

After his various vicissitudes of fortune he had been living at his home in France, the Château La Grange, which his wife had inherited from her mother. Feared, yet respected by his King, Lafayette was forced to live in comparative obscurity. His very movements were constantly watched by governmental agents, and he sailed from Havre without the demonstration which his political friends and associates wished to accord him upon his departure for the country where Republican principles held sway. Refusing the offer of a frigate from Congress, he took passage in the packet ship " Cadmus," Captain Allyn, in company with his son, George Washington, a man of forty, and his secretary, Monsieur Le Vasseur. The good ship " Cadmus," soon to become famous from bringing such distinguished visitors to these shores, slipped quietly out of the harbor of Havre on July 14th, 1824. After an uneventful voyage, she was passing through the Narrows, with a favorable wind, on Sunday, the 15th of August, when she was hailed by a small boat with two mysterious passengers, who, after a whispered conversation with

Captain Allyn, departed as quietly as they had come. When the ship reached Tompkinsville, Staten Island, her anchor was dropped, much to the chagrin of her passengers, who, fatigued by a long voyage, wished for the comforts of the shore. Still, nothing was known about the demonstration which was to take place. Indeed, the Marquis, little realizing what was in store for him, displayed intense anxiety about the expense of the trip which he had hoped to make throughout the country.

Soon a gaily decorated fleet of steamers, with bands playing, was seen approaching, and numerous were the conjectures as to what all this meant. However, all doubt was quickly dispelled when a Committee of Welcome boarded the "Cadmus" and greeted the distinguished personages. The day being Sunday, the triumphal entry of the "Cadmus" was postponed until Monday, and Lafayette spent the day as the guest of Vice-President Tompkins, at his residence on Staten Island.

The next day, shortly after noon, Lafayette embarked upon the steamer "Chancellor Livingston," where he was welcomed by the Mayor, the members of the Corporation, his old comrades in arms, the members of the Order of the Cincinnati, and the officers of the Army and Navy stationed in New York. The

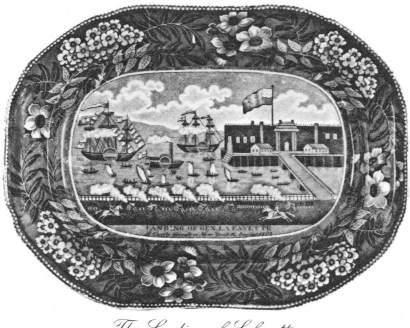

The Landing of Lafayette.

steamer "Robert Fulton," with her yard-arms manned
by two hundred sailors from the Brooklyn Navy Yard,
headed the procession, which was composed of a large
number of lavishly decorated steamboats of various
descriptions. The "Cadmus," in tow of a steamer,
brought up the rear.

Upon reaching the Battery the celebrities landed
at the steps of Castle Garden. This scene has been
perpetuated by the Messrs. J. & R. Clews, who, with
great enterprise, secured an original sketch showing the

main features of this great celebration. The artist has pictured Castle Garden, its roof filled with people, the artillery firing a Major-General's salute in honor of the arrival of the old veteran, and the officers in command riding up and down in the rear of the guns. The steamer "Robert Fulton," dressed with flags and her yard-arms manned, is visible; and that grand old steamer "Chancellor Livingston," the "pride of the river," decorated simply with the flags of the City, State and Nation. The little "Nautilus" is also shown, and the water near the shore is dotted with small craft of every description.

An exceedingly rare engraving by Samuel Maverick of a drawing by Imbert of this important event, convinces me that the latter artist supplied the sketch which Clews so extensively reproduced. Though the engraving pictures this scene as it appeared from the harbor, yet the same details in the surroundings, the positions of the guns, officers, troops and vessels, and the water dotted with sail-boats and wherries, leave little doubt that both of these pictures were the work of the same artist.

The enterprise of the potter was well rewarded, for there was immediately a great demand for his earthenware. Enormous dinner, tea and toilet sets were made with this decoration, and they were distributed throughout the country.

On leaving Castle Garden, Lafayette reviewed the militia at the Battery, and was driven to the City Hall through streets crowded from sidewalk to housetop.

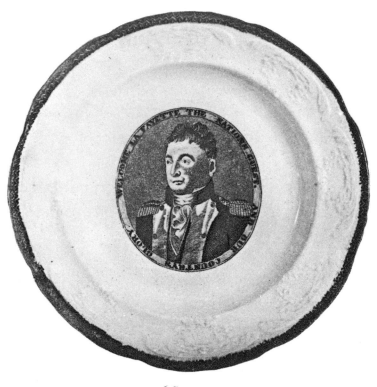

Lafayette.

Here he was formally welcomed by the Mayor, to whom he made a response characteristic of his devotion to the principles upon which this Nation was es-

tablished. After receiving from the steps of the City Hall a marching salute from the military, who then dispersed, he was given a reception by his old comrades

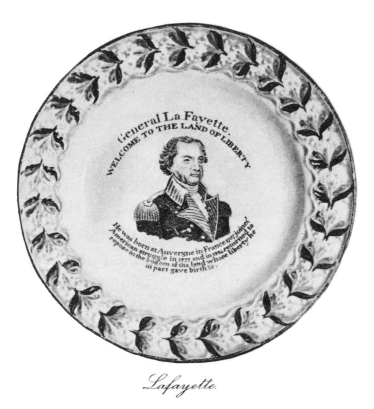

Lafayette.

in arms, the members of the Order of the Cincinnati, when many pleasant friendships were renewed.

Lafayette's stay in the city was one continued ova-

tion. To Americans Lafayette was a reminder of the stirring scenes which gave to them the freedom which they so well enjoyed, and they showered upon him the honors due to other great men, his comrades in the Revolution, of whom he was almost the only survivor. Both political parties vied with each other in doing him homage. Those of the Democratic or "French" party, with their strong anti-English prejudices, welcomed him as their own, while their opponents claimed him as the adopted brother of their dead leader, Hamilton. Both parties saw in this aged veteran the gallant young French nobleman who, in his devotion to Liberty, had given his sword, his fortune, and even his blood to aid the cause he loved so well. He was welcomed by a united people as "The Friend of Washington," and his travels throughout the land awakened that patriotism which is latent in all Americans, and which only needs some incident to make it burst into flame.

Leaving the City Hall, the Marquis was escorted to the City Hotel, where sumptuous apartments had been prepared for his use. That evening a dinner was given in his honor at this famous hostelry by the members of the Corporation. Excusing himself early, he went to pay his respects to the widow of his lamented friend, Alexander Hamilton, and upon his return to the hotel

Washington and Lafayette.

found it ablaze with illuminations, the lights in the windows of the second story being arranged to spell out the word L A F A Y E T T E .

It is not within the province of this volume to describe in detail the various entertainments given in his honor—the special performance at the Park Theatre of the "Siege of Yorktown," his reception at the Histori-

cal Society, the concert given at St. Paul's Chapel by the choral societies of the city, nor the great ball at Castle Garden. It is sufficient to say that the enthusiasm aroused was almost hysterical. Watch ribbons, belt buckles, and even handkerchiefs exhibited his likeness; the old red, white and blue cockades appeared on the streets, and ladies' gloves, whose buttons bore his portrait, were most popular with the fair sex. It certainly would have been remarkable if this welcome to the illustrious visitor had not afforded the inspiration for the decoration of many pieces of pottery.

The following poorly printed portraits of Lafayette met a ready sale:

1st. A medallion, taken from the French copperplate, printed by the elder Chardon and drawn and engraved by Geille (see page 122). The inscription around the portrait well illustrates the prevailing sentiment, "Welcome, La Fayette, the Nation's Guest and Our Country's Glory."

This same medallion also appears on each side of the beautiful dark blue pitcher shown at the beginning of this chapter. Both of these pieces are the work of the Messrs. Clews.

2nd. Another pitcher bears what appears to be almost a caricature of the grand old Frenchman, yet the inscription surrounding it shows the feeling of a grate-

ful people : " General La Fayette was born at Auvergne, in France. At 19 he arrived in America in a ship furnished at his own cost in 1777, and volunteered in our army as a Major-General. At Brandywine he was

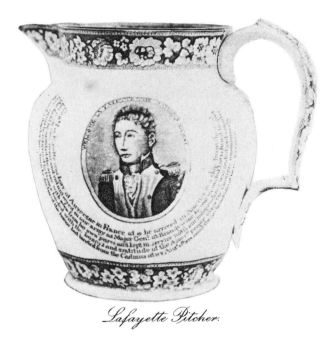

Lafayette Pitcher.

wounded, but refused to quit the field ; he assisted the army with 10,000 from his own purse, and kept in service until our independence was sealed and country free ; in 1784 he returned to France loaded with honors and the gratitude of the American people ; in 1824 the

127

Congress unanimously offered a ship for his return ; he declined the honor, but landed from the Cadmus at New York August 15th, 1824, amid the acclamations of 60,000 freemen."

3rd. A different portrait appears upon other pitchers and plates (see page 123), with the following sentence placed beneath the portrait :

"He was born at Auvergne, in France, in 1757 ; joined the American struggle in 1777, and in 1824 returned to repose in the bosom of the land whose liberty he in part gave birth to."

4th. A rather better portrait is found upon another pitcher made "In commemoration of the visit of Gen'l La Fayette to the U. S. of America in the year 1824." (See page 81.) The other side of this pitcher bears a portrait of Washington (see page 91), while upon the front, beneath the spout, are found the words, "Republics are not always ungrateful."

This undoubtedly refers to the long-deferred recompense to Lafayette for the fortune that he expended during the Revolution in behalf of the Continental cause.

On a medallion in the centre of a large dinner plate are found poorly executed portraits of Washington and Lafayette, surrounded by the words "Washington," "July 4, 1776," "Welcome La Fayette," "The Nation's

Guest," "Aug., 1824." The back of the plate bears the mark, "R. Stevenson & Williams, Cobridge, Staffordshire." (See page 125.)

The ship "Cadmus" also received a warm welcome; and when Captain Allyn gave a reception it was visited by two thousand people.

Four different views of the "Cadmus" covered the centres on various sizes of plates:

1. At anchor: on dinner plates (see illustration at head of this chapter).

2. Another view, evidently showing the vessel while lying off Staten Island. In the distance appears an excursion boat dressed with flags in honor of Lafayette. This scene is found on the breakfast plate illustrated on page 138.

3. Under full sail: on tea plates.

4. At anchor: on cup plates.

The sea-shell borders on all these plates, with the exception of the second, are recognized as the work of E. Wood & Sons. The same potters sent to this country four views of Lafayette's home, La Grange:

1st. "Southwest view of La Grange," appearing on the large platter shown on page 131.

2nd. "Northwest view of La Grange," a poorly printed view, covering the sides of a large soup tureen.

3rd. "La Grange, the Residence of the Marquis

La Fayette" (see page 134), showing the entrance to the château and the owner, with his daughter and grandchild, in the foreground. A medium-sized litho-

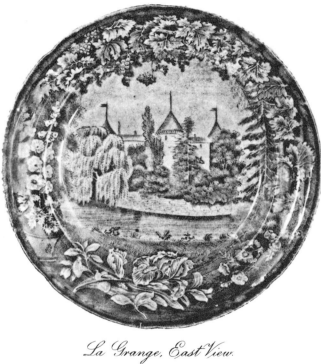

La Grange, East View.

graph of the same scene had a large circulation throughout the country at the time of Lafayette's visit.

4th. "East view of La Grange," showing the moat and wall.

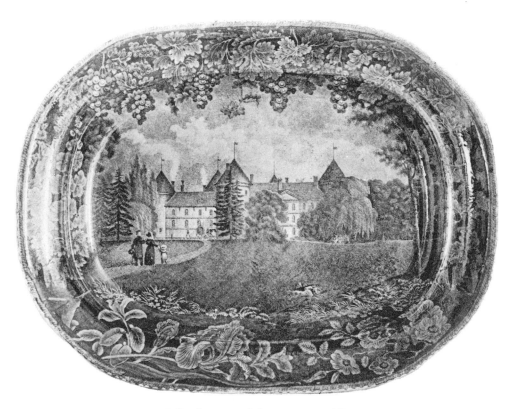

La Grange Southwest View.

The baronial estate, of which the Château La Grange was the stronghold, was founded by Louis VI about the beginning of the twelfth century. It was thirteen leagues east of Paris, near Rosay en Brie. The architecture of the château was Norman. It was long the residence of the princes of Lorraine. In 1801 it came into the possession of Madame Lafayette by inheritance.

Shattered in fortune and weary of public life, Lafayette gladly sought retirement there, and began slowly to restore its former grandeur—for the château had been unoccupied for many years, was bare of furniture and sadly in need of repairs. The main portion of the building was about one hundred feet long ; to this were joined, at right angles, two wings of the same length. These, in former times, were connected by a gallery. A double moat for defence surrounded the structure. Under Lafayette's supervision the condition of the estate rapidly improved. The grounds were laid out with the assistance of Robert, the great landscape painter. At the time this pottery was made five hundred of its eight hundred acres were under cultivation. A long roadway through the forest led to the entrance. A stone bridge over the moat had replaced the drawbridge of former times. The towers at the entrance were covered with ivy planted by Charles Fox, who,

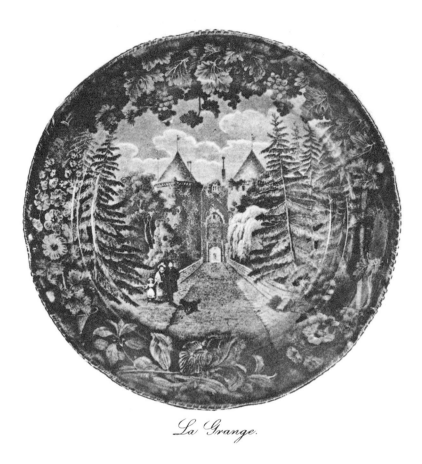

La Grange.

with his wife, visited here after the Peace of Amiens
(1802). Lafayette's library, on the third floor of one of
the towers, was his chief delight. Its walls were hung
with portraits of Washington, Franklin, the Adams
(father and son), Jefferson, Hamilton and other famous
Americans, the friends of his youth. Indeed, the whole
furnishing of this room showed that Lafayette's devo-
tion to and interest in this country did not cease when

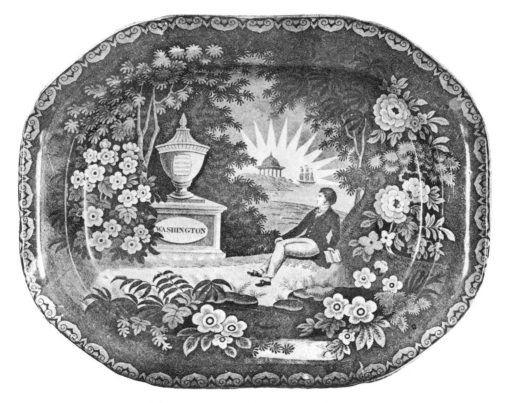

Lafayette at Washington's Tomb.

he returned to take up the cause of liberty in his own land.

This set was exceedingly popular, for the Château La Grange was as dear to the hearts of the people as Mount Vernon, and few American travelers when in France failed to visit the home of him to whom America and the cause of liberty throughout the world owed so much.

Another design relating to Lafayette, extensively used in the decoration of tea and coffee sets, and in some few instances of plates and platters, is a poorly executed drawing of Lafayette at the tomb of Washington. Just why the artist selected a funeral urn with Washington's name on the base instead of the real tomb at Mount Vernon is not known. Still the sentiment displayed led to an enormous sale of these pieces.

The platter shown in the illustration has printed upon its back in blue the name " Harris and Chauncey, 70 Wall Street." These gentlemen were extensive importers of earthenware. A search in the city directories proves that they occupied 70 Wall Street only from 1826 to 1829, and thus we are enabled to date this design between the years 1824, the time of Lafayette's visit, and 1829, when the firm left 70 Wall Street.

A similar view bearing the name of Franklin upon the tomb is found on various pieces of hollow ware.

Upon leaving New York, Lafayette, after making a triumphal journey through New England, during the next twelve months visited the principal cities along the seaboard. From New Orleans he ascended the Mississippi and Ohio Rivers, and thence made the tour of the Great Lakes. The frigate "Brandywine" carried him back to Havre, where he arrived October 5th, 1825, ready to take part in the events which preceded the Revolution of 1830.

The Cadmus.

Erie Canal Inscription.

THE ERIE CANAL

THE following year New York City witnessed another celebration which was on even a larger scale, but of a different nature— namely, that in honor of the opening of the Erie Canal. The welcoming of Lafayette might be well termed a fête of patriotic memories, for by it the atten-

tion of the people was directed to the remembrance of the past.

The celebration at the opening of the Grand Canal, on the other hand, marked the beginning of a new era, in which the fondest dreams of the promoters of this stupendous undertaking were realized. The arrangements for the festivities in this city were perfected under the auspices of the Corporation, with the hearty co-operation of the citizens and various local societies ; for New Yorkers were well aware that this waterway would open up to their commerce not only the interior of the State, but also the vast territory tributary to the Great Lakes, and firmly establish their city's commercial supremacy, which up to this time had been seriously threatened by Baltimore and Philadelphia. These cities, through the advantage of natural waterways and governmental turnpikes, held almost a monopoly of the trade of the great and growing West, which state of affairs was, however, completely changed by the cheapened transportation afforded by the new route, and New York became the distributing centre for this boundless territory.

Great were the advantages reaped by the State whose " enterprise and resources " had pushed through this work ; yet these were small as compared with benefits derived by the people of the territory bordering

on the Great Lakes, who were thus enabled to find another market for the products which the matchless fertility of the soil made it possible for them to produce in such unsurpassed abundance. Indeed, the tremendous and rapid development of that section of the Union was almost entirely due to the connecting link made between lake and ocean.

On October 26th, 1825, the canal was finally completed, and at ten o'clock in the morning the first canalboat, the "Seneca Chief," entered the canal from Lake Erie on her triumphal passage to the sea. The exact moment of starting was communicated to the city by the firing of cannon placed at regular intervals along the waterway, and eighty minutes later the booming of guns notified the residents of New York that the Erie Canal was ready to contribute its share toward the development of the Nation.

Convoyed from Albany by a number of river craft, the aquatic procession reached New York on November 4th, where it was met by a great flotilla, which, after various manœuvres, escorted it to Sandy Hook, where, with appropriate ceremonies, the waters of Lake Erie, the Mississippi, the Columbia, and of the twelve other great rivers of the world flowing into distant seas, were solemnly mingled with those of the Atlantic Ocean—a fitting symbolism of the commerce hence-

forth to be carried on between the undeveloped West and foreign nations.

Owing to the approaching elections the ceremonies on land were entirely of a civic nature, the Constitution of the State providing that no military bodies should carry arms within twelve days of the time appointed for the casting of the ballot. However, this in no way interfered with the picturesqueness of the procession. Seven thousand men appeared in line. The various societies and guilds vied with each other in presenting an attractive appearance, and were all accompanied by transparencies and floats enthusiastically portraying the greatness of the canal. On November 7th the ceremonies were fitly concluded by a grand ball given by the military in honor of the occasion. The City Fathers, with praiseworthy forethought, prepared an extensive memoir of this celebration. Cadwallader D. Colden was entrusted with editing this volume of nearly five hundred pages, most profusely illustrated. These illustrations undoubtedly furnished subjects to the English potters for the decoration of various pieces of pottery illustrative of the Erie Canal.

The first of these may be properly called the "Erie Canal Inscription" plate (illustration page 139). On its border appears a canal-boat, such as was used to carry passengers. There is little doubt that this is a picture

of the " Seneca Chief," which carried the guests of honor on the first trip made through the canal. The view of the canal locks, while differing somewhat in minor details, bears a striking similarity to that view used by Samuel Maverick, New York's well-known artist, designer and engraver, upon the ball tickets and badges, reproductions of which are inserted in Mr. Colden's book. Indeed, the whole appearance of the plate, with its clean-cut inscription surrounded by an artistic wreath, also distinctly characteristic of Maverick, unalterably points to the design as the work of this artist. In fact, it is more than probable that the copper-plate used in the printing of these pieces was made by him at the request of some dealer in earthenware, who sent it to Staffordshire for a decoration which would insure a ready sale for the articles it embellished. The inscription certainly is a beautiful tribute to De Witt Clinton, who used his remarkable talents to bring this scheme of inland navigation to a successful end, and also to the people of the State, who supplied the funds.

De Witt Clinton first became deeply interested in this project at a meeting of the merchants of New York at the City Hotel in 1810. The War of 1812 forcibly demonstrated to the Legislature of the State the absolute necessity of a better means of communication be-

tween the seaboard and the borders of the State ; for the armament of the little fleets which secured such laurels for the American Navy on Lakes Erie and Champlain was transported from the seaboard by almost superhuman efforts. However, after fierce opposition, the persuasive eloquence of Clinton secured, in 1817, the passage of an Act of Legislature which provided funds for the construction of a canal some three hundred and sixty-three miles in length, forty feet wide on the surface and eighteen on the bottom, with a channel four feet in depth. Ground was broken for it on the Fourth of July in the same year.

The intense opposition to the canal was due to the fact that the whole scheme was judged chimerical, many people believing that the State had no right to sink its money in a work the success of which was problematical. The political enemies of Clinton derisively referred to the undertaking as " Clinton's Ditch," which term, when the successful outcome of the work became apparent, was retained by Clinton's supporters. The first cost of the canal amounted to more than nine millions of dollars, an amount equal to that which has been squandered in the past two years in improving it.

The companion plate is a splendid reminder of what the cities of this State owe to the Erie Canal. In 1822

the section of the canal extending from Rochester to Utica was opened, a distance of one hundred and sev-

Utica Inscription.

enty-four miles. The date on this inscription leads to the belief that these plates must certainly have been placed on the market about the time of the Erie Canal

145

celebration, though just why the date 1824 was chosen instead of that of the following year is not apparent. Possibly the wording in the centre was a famous toast used on some occasion in the interior of the State which attracted the ear of a designer employed in the earthenware trade or manufacture.

These two "inscriptions" were also printed upon the two sides of pitchers, while upon the front, beneath the spout, are seen views of a series of canal locks, a canal-boat, and the omnipresent American eagle (see page 139).

Mr. Colden's book also provided Enoch Wood with three pictures which were not only used for the decoration of plates of sundry sizes, but also of hollow ware of various descriptions. These prints were first published at Albany in two volumes giving the "Laws of the State of New York in relation to the Erie Canal, as well as a complete documentary history of the undertaking." The copper-plate illustrations to this work were presented to the State by the Hon. Stephen Van Rensselaer, who employed the well-known landscape artist, J. Bights, for securing views of various portions of the canal.

The first of these shows the "Entrance of the Erie Canal into the Hudson at Albany." In the distance to the right is seen the old Van Rensselaer Manor House,

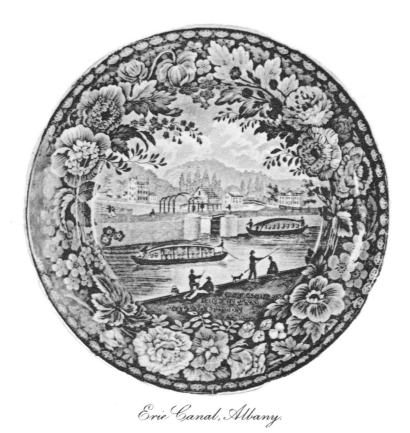

Erie Canal, Albany.

which remained standing until about ten years ago,
when it was pulled down. Portions of it were carried
to Williamstown and used in the construction of one of
the Fraternity buildings connected with the college.
The small building near it was known as the "Tea
House," and still remains. In the centre, over the
entrance proper, are the frames of the triumphal arches
which were profusely decorated on the occasion of the

celebration held at the opening of the canal into the Hudson River. In the centre is the warehouse of Ebenezer Wilson, and to the extreme left the house of Stephen Van Rensselaer ; this is still standing, and is now St. Peter's Hospital.

Interesting features of this view are the canal-boats of two different types. The one to the left was constructed to carry freight, while the other is one of the famous passenger boats.

The latter were from sixty to seventy feet long, and had two cabins, the smaller of which, containing eight beds, was devoted to the ladies. A long table, on which the meals were served, ran the length of the main cabin, and along the sides of this room were a row of lockers, which at meal times answered for seats. When the hour for retiring approached—for these packets traveled by night as well as by day—mattresses were placed upon the lockers. American ingenuity supplied another set of beds above these. Panels, which by day hung hinged to the walls, were at night extended and supported by ropes attached to the roof of the cabin, thus affording another row of beds. This undoubtedly gave Mr. Pullman the idea he so successfully evolved. The cabins contained small libraries, which enabled the passengers to while away the monotony of the journey. Each of these boats was also

provided with a bar, an institution which, even at this period, seemed indispensable in public hostelries and passenger boats of all descriptions. The kitchen boasted furnishing, at moderate expense, a table equalled by few hotels in the country. The cost of traveling was uniform, the fare being two and one-half cents per mile. The charge for dinner was thirty-one cents, while breakfast and supper were supplied for twenty-five cents each ; a night's lodging cost only twelve and one-half cents. The average rate of speed of these packets rarely exceeded three and one-half miles an hour.

The " View of the Aqueduct Bridge at Little Falls " (see page 150) shows one of the great engineering feats at which the whole country marveled. At the left is seen the canal raised by a wall of masonry thirty feet above the river. In the centre are the rapids of the Mohawk River, spanned by the bridge of granite which supported the canal in its passage across the river.

The last of these interesting views pictures the great "Aqueduct Bridge at Rochester " (see page 152), whose ten arches of hewn stone carried the canal across the Genesee River, making a span eight hundred and fifty feet long. To the left is a group of taverns, which, from their well-dispensed hospitality, became well known through the western part of the State.

The plates described have long been attributed to the potteries of Clews. Contrary to custom, the pieces

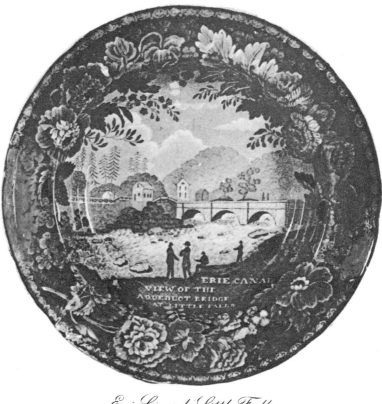

Erie Canal, Little Falls.

fail to have any of the characteristic maker's marks. The reason for this is not apparent. Possibly the great prejudice against articles of English manufacture, already

alluded to, may have caused the makers to leave off any indications of their being the production of British enterprise. However, I have recently come across a large wash-bowl showing the "Entrance of the Erie Canal into the Hudson at Albany," surrounded by the same characteristic border which the plates have. This has upon its bottom the faintly impressed mark of E. Wood & Sons, and settles the question as to what potter we are indebted for these interesting mementoes of the great Canal. Ralph Stevenson also availed himself of these prints for decorating the lower edges of a series of plates.

The canal at Albany appears on a plate, the centre of which shows a view of Faulkbourn Hall, England (see page 155). On the upper edge are placed the four medallion portraits of Jefferson, Lafayette, President Washington and Governor Clinton. The decorations on these plates are more ambitious than on any others made for the American market, requiring no less than seven * separate applications of the printed oiled paper. This is proved by the fact that other plates differ from that shown in the illustration only in the arrangement of the portraits and the selection of other views of the Erie Canal for the lower edge.

* One printing for the centre, another for the border, and five for the view and portraits placed in the border.

The same medallion portraits are seen in varying
number on plates of the "acorn border" series (R. S. W.),
showing prints of the Park Theatre (see page 154), City

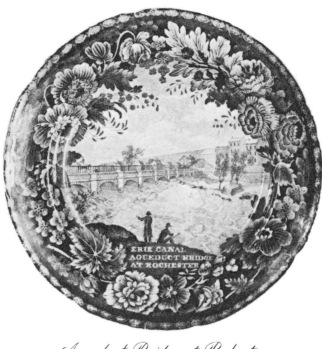

Aqueduct Bridge at Rochester.

Hotel and Columbia College, which came from the pot-
teries of Ralph Stevenson. They are also found upon
some of the "vineleaf border" series (R. S. W.) as
well as upon one of the "flower and scroll border"

series (A. Stevenson). The importance of these plates is very great, for they certainly prove conclusively that the plates impressed with the familiar mark " A. Stevenson " are not, as universally considered, the work of the potter who lived at Cobridge and who succeeded to the pottery of Messrs. Bucknall & Stevenson in 1808, but of Ralph Stevenson. A. Stevenson was succeeded in 1818 by the firm of J. & R. Clews, some of whose wares have been described in the previous chapter.

The absurdity of this error is plainly seen from the fact that the stamp " A. Stevenson " appears on plates showing views of the Erie Canal and portraits of Lafayette, "the Nation's Guest," which were not printed until six years after the Messrs. Clews succeeded A. Stevenson. The events which they recall did not occur till 1824 and 1825. That the Stevenson was Ralph Stevenson is certain, for the identical portraits and scenes appear on the characteristic acorn border plates of Ralph Stevenson. This proof is strengthened by the fact that in 1828 Stevenson combined his forces with those of S. Alcock, a neighboring potter, better known for his ingenuity and taste than for his success in making a market for his wares.

Undoubtedly the trade-mark " A. Stevenson " was adopted with the view of retaining the prestige which

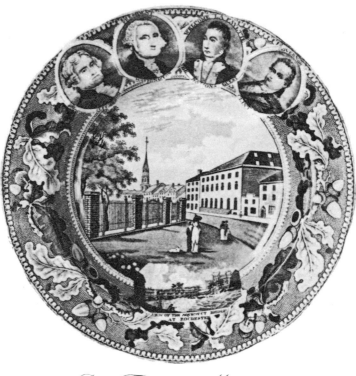

Park Theatre and Medallions.

the former products of R. Stevenson's pottery, many reproductions of which are to be found in this volume, had secured in the American market.

Beneath the spout of a beautiful large pitcher whose two sides are covered with views of the Erie Canal appears a picture of the old Dutch Church at Albany (see last page of this chapter). Above the church is to be seen the inscription, "Erected 1715—pulled down 1806." The pitcher bears upon its bot-

154

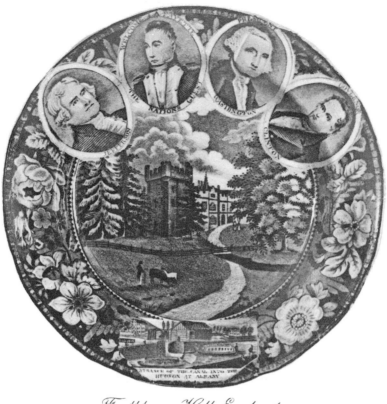

Faulkbourn Hall, England.

tom the mark, printed in blue, "Stevenson's stone china."

The first congregation in the settlement, which has since developed into the City of Albany, worshipped in a little log-house, under the pastorship of one Johannes Megapolensis Junior, whose salary was paid by the Patroon Kiliaen Van Rensselaer. The first services were held in 1642. Albany, or Fort Orange, as it was

then called, was little more than a trading-post composed of log-houses surrounded by palisades for defence. Not until 1647, when the settlement was twenty-four years old, did it possess its first stone-house. The completion of this was most gloriously celebrated by the consumption of one hundred and twenty-eight gallons of liquor. In 1656 a new house of worship was erected near the old fort, at the intersection of what is now State Street and Broadway. This building was planned to afford a place of refuge against attack from the Indians, and was built in the form of a block-house ; its walls were loopholed for muskets, and upon its roof were mounted three tiny cannon, which commanded the three roads converging there. Its bell and pulpit were sent from Holland in 1657. The former was the gift of the Directors of the Amsterdam Chamber of the West India Company. These men also contributed seventy-five guilders toward a small pedestal pulpit, the twenty-five beaver skins donated by the members of the congregation not being sufficient for its purchase. The new church—the one pictured on the pitcher—was erected in 1715. It was built of stone, and the walls and roof were raised around and over the original structure, which was kept intact until the new building was finished, so that there might be as little interruption as possible to the services held in

the old building. The church contained a number of memorial windows contributed by its worshippers. This property was sold to the city in 1806, and upon its demolition many of its original stones were worked into the church in South Street.

Dutch Church at Albany.

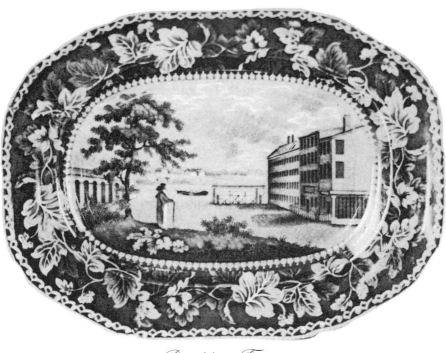

Brooklyn Ferry.

VIEWS ALONG THE EAST RIVER AND OF HOBOKEN, NEW JERSEY

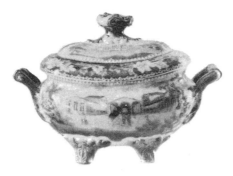

In the year 1821 Fulton Market was built upon ground purchased by the city in response to the demands made by the great increase in the growth of this section of the city. The total cost of the building and land was $220,000. A print, engraved by Messrs. Rawdon,

Clarke & Co., and published in Goodrich's " Picture of New York " (1825–1828), furnished Stevenson with the view on the gravy-dish shown in the illustration.

This potter secured an original sketch, probably by C. Burton, which he successfully applied to the centre of a small platter labeled " Brooklyn Ferry," which is reproduced at the head of this chapter. To the left is seen Fulton Market; to the right a row of stores and warehouses with which the shore of the East River was crowded, for this side of the river was the home of the shipping interests, which even at that time were of tremendous proportions.

In the centre of the platter is pictured the gate leading to the ferry, popularly called the " Ferry Steps." In midstream is the first Brooklyn steam ferryboat, the " Nassau," built upon the model of the catamaran, with a large wheel in the centre. The lease of the privilege of operating this ferry was purchased from the municipal authorities by Robert Fulton and William Cutting. Beekman's Slip, the site of the New York landing, was sold to the city by Peter Schermerhorn, and Ferry (now Fulton) Street was opened up.

The " Nassau " was launched in 1814, and immediately found favor with the public. The boat made half-hourly trips, commencing a half hour before sunrise and continuing until shortly after sunset. Then

this little boat had other duties to perform. In the
Long Island "Star" of July 6th, 1814, is found the fol-
lowing account of a popular excursion and headed :

RATIONAL AND REFINED PLEASURE

"On Thursday evening last (June 29th) the beau-
tiful steamboat 'Nassau,' having been fitted up for an
excursion of pleasure, received on board about two
hundred and fifty persons, principally inhabitants of
Brooklyn, and also an excellent band of music from
New York, and left the slip amid the huzzas of an ad-
miring multitude. She was beautifully illuminated and
moved majestically upon the water, streaming the
white waves in the rear by the force of her excellent
machinery. The moon shone with a kindly radiance,
and the air was just sufficiently cool. As she passed
up the East River near the city, multitudes assembled
on the docks and cheered responsive to the enlivening
music of the band. On the water were a multitude
of small boats with people of all colors and both sexes,
vainly trying to keep up with the steamboat and catch
the droppings of music and merriment which prevailed
on board. On her return, when near the flagstaff on
the Battery, her way was stopped awhile, when

"'The brisk, the bold, the young and gay'

mingled in the sprightly dance. The boat proceeded

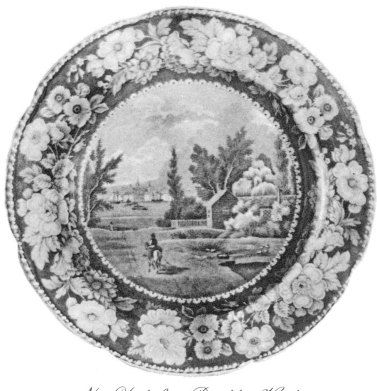

New York from Brooklyn Heights.

some distance up the North River, and on her return
again stopped at the Battery to serenade the crowds
there assembled. She next passed around that grand
military establishment, Governor's Island. The silence
of the night, the majestic castle, the measured step of
the sentinel, his arms occasionally showing, shining in
the moonbeam ; the dark forest of Red Hook on the
one hand and the neat white dwellings of our brave

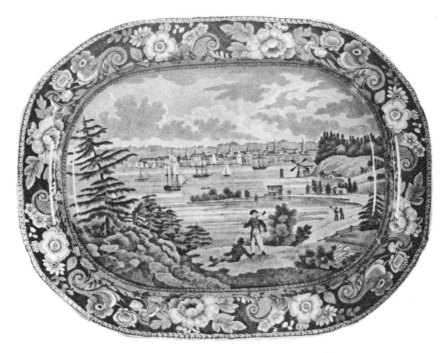

New York from Brooklyn Heights.

defenders on the other—all, all conspired to give to 'the soul of sentiment' the most enrapturing emotions. This is a refinement, a luxury of pleasure unknown to the old world. Europe, with her boasted excellence in the arts and science, in vain may look at home for any parallel. The Captain, lordly as old Neptune, drives this splendid car regardless of wind and tide, and is able to tell with certainty the hour of his return. Honored age and sprightly youth, the beauteous fair and their manly admirers, all who have partaken, will dwell with delight on the innocent and varied charms of the 'Nassau's merry excursion.'"

Another view, and a more faithful one, of this little boat is found upon a plate also made by Stevenson, entitled "New York from Brooklyn Heights, by W. G. Wall" (illustration page 162).

Mr. Wall was a young Irishman who came to this country in 1818, and in a few years acquired a reputation for beautiful landscapes in water-color. His pictures are said to have brought as much as four hundred dollars—an unprecedented sum at that time for the work of local artists in water-color. Much of his work was engraved and reproduced in color.

Besides this view, which shows in the foreground Brooklyn Heights in the early part of this century, another picture of New York, made by this artist from a

different part of Brooklyn, was used by Stevenson. In the foreground is that portion of Brooklyn then known as Red Hook, now as South Brooklyn. On the water's edge Pierrepont's Distillery, with its picturesque wind-mill, stands out prominently, and near it are the ware-houses where its famous "Anchor" brand of gin was kept to mellow until fit for the market. Beyond is the river, alive with various types of merchantmen, and the river bank lined with storehouses. Among the church spires which can be plainly seen against the sky may be noted those of Grace, Trinity, the First Presbyterian, Scotch Presbyterian, Middle Dutch, St. Paul's, Brick Church, and St. George's Churches. The roof of the City Hotel is conspicuous. This view of Wall's was engraved by I. Hill and published in color in large folio size in 1823.

Another print, "New York from Weehawk," the work of the same men and published the same year, was also made use of by Stevenson (see page 167).

The following drawings by Wall also appear upon Stevenson's pottery :

1. "On the Road to Lake George " (see page 77).

2. "Junction of the Sacondaga and Hudson Rivers " (see page 57). The print which supplied this view was one of a series entitled "Views of the Hudson River," published in 1825.

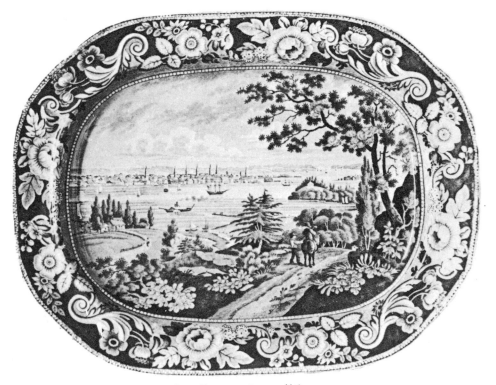

New York from Weehawk.

3. "View of Troy from Mount Ida." This was obtained from the same series.

4. "New York Alms House" (illustration, page 100).

Thomas Jefferson was so impressed with the work of this young artist that, while President of the University of Virginia, he requested him to fill the chair of drawing at the college at Charlottesville. This call was refused, as the compensation offered was not sufficient to tempt Wall to leave New York.

An interesting picture "Hurl Gate, East River" (see following page), by Joseph Stubbs, has been handed down to us on pottery. Hell Gate, or Hurl Gate, had long been the terror of mariners, and many a fine boat was wrecked by its treacherous eddies. As far back as 1678 the journal of a traveler describes it as being "as dangerous as the Norway Maelstrom," and that "in this Hell Gate, which is a narrow passage, runneth a rapid, violent stream, both upon flood and ebb ; and in the middle lieth some islands of rocks upon which the current sets so violently that it threatens present shipwreck ; and upon the flood is a large whirlpool which sends forth a continual hideous roaring."

Its shores were the favorite haunt of Washington Irving, who, in his "Knickerbocker History of New York," describes at length the trials of the Dutch navigators in venturing to explore its waters.

Beyond the Sound steamer in the illustration is pictured Mill Rock, which, with its powerful battery and staunch block-house, made New York secure from attack on this side during the War of 1812.

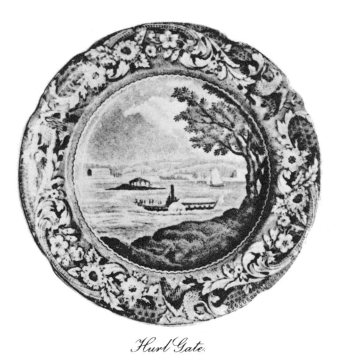

Hurl Gate.

The view upon this plate, as well as the one upon the one next described, appears on nothing but the dark blue earthenware which graced the dining-tables nearly four generations ago.

A beautiful ten-inch plate, "Highlands, North River," also by Joseph Stubbs, gives us a view of one

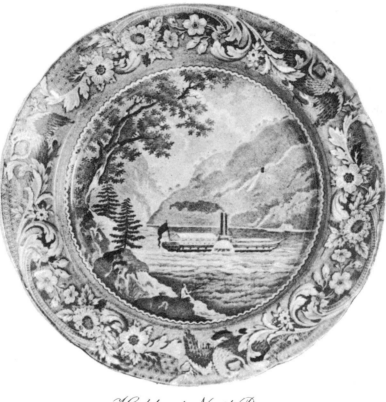

Highlands, North River.

of the many early types of steam craft used in the navigation of inland waters. A contemporary print leaves no doubt that the steamer "Fulton," famous through-

out the country for her speed, was introduced by the artist into this picture.

The " Fulton " was launched in 1813, and was the first steamboat constructed to rely upon her engines alone ; all other boats destined for river navigation had been hitherto furnished with masts and sails. She was originally built for passenger traffic on Long Island Sound. Driven in by the British fleet, she plied between Albany and New York, and later in her career ran between New York and Providence.

Like the little "Nassau," she, too, was used for pleasure parties. An article in the "Columbian" of June 4th, 1814, describes one of these excursions as follows :

" STEAMBOAT FULTON.—We understand that no less than 140 persons were carried in this superb vehicle to Sandy Hook on a voyage of pleasure on Thursday last. On Friday, in consequence of the weather, the company was smaller, but the trip equally interesting to the passengers (especially to some from the country), who had the pleasure of feeling the refreshment of the sea breeze, with some of its beneficial effects upon the stomach. They arrived, however, at the cove in two hours and five minutes, and came to anchor in smooth water, and enjoyed their dinner with an excellent relish."

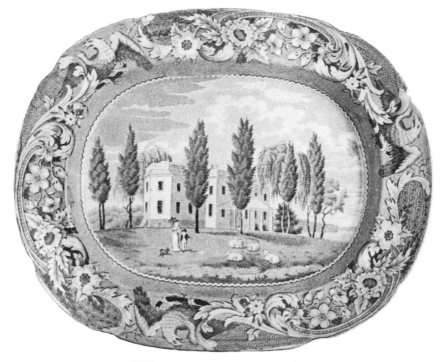

The Stevens House in Hoboken.

Another bit of pottery which properly belongs to the New York series pictures the suburban home of Colonel John Stevens, at Castle Point, Hoboken, New Jersey. This house was built and used as a residence by one Colonel Samuel Bayard. This gentleman was a strong Loyalist, and raised a regiment of Tories for the King's service. At the close of the war his estates were confiscated, and his Hoboken property was purchased in 1784 by Colonel Stevens at public sale.

To the latter, almost as much as to Fulton, belongs the honor of being the inventor of steamboat navigation, for his boat, the "Phœnix," was launched and proved a success only a few weeks after Fulton's triumph was assured. Colonel Stevens's whole life was devoted to mechanical engineering, and the many improvements in the engines which followed were entirely due to his genius. In 1812, realizing the importance of steam as a motive power upon land, he published a pamphlet on railroads in which he indicated the methods of using steam as a motive power upon land, and predicted its use. In 1825, within his spacious grounds at Hoboken, he built and operated upon a circular track the first steam engine run in this country.

Owing to the lavishly dispensed hospitality of the owner, this house became famous, and it was natural

for Stubbs to avail himself of a print which appeared among a series of views entitled the "Country Seats of the United States of North America," which were drawn, engraved and published (1808) by W. Birch, the well-known miniature painter, and reproduced in 1824 at Stockholm, in an atlas compiled by Axel Klinkowström.

This view appeared on various pieces of an elaborate dinner set.

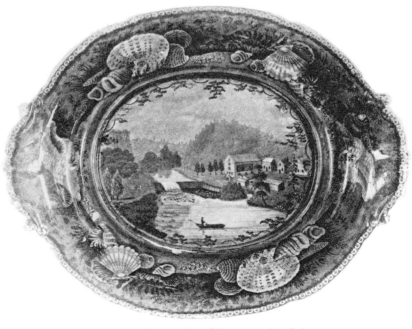

Hope Mill, Catskill, N.Y.

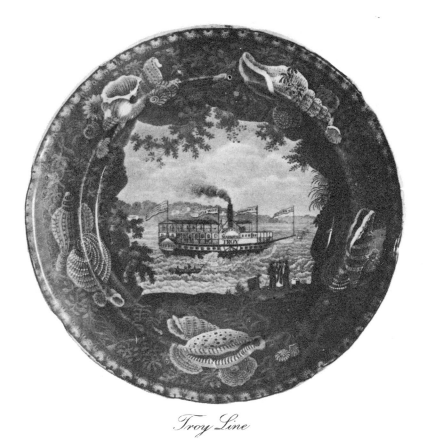

Troy Line

HUDSON RIVER AND NEW YORK STATE VIEWS

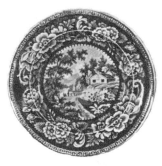

ENOCH WOOD was a lover of the beautiful, and to him we are indebted for a charming set of views of the Hudson River and noteworthy bits of scenery in the interior of the State. He left also two pictures of steamboats belonging to popular lines of travel. The first

one shows a view of the Troy Line boat, "Chief Justice Marshall," which, launched in 1826, became the favorite packet between New York and Albany. The steamer is seen in the act of drawing in a small boat after having landed some passengers upon the river bank.

This process of disembarkation is vividly described in Basil Hall's "Travels in North America," in the years 1826 and 1827, as follows:

"These embarkations and landings are cleverly executed. When the steam vessel comes within five hundred yards of the dock or wharf, a bell is rung on board to give warning of her approach. A little boat is then lowered into the water with two hands in it, and is towed alongside until nearly abreast of the dock. The men now put off, and from the velocity acquired by the steam vessel easily manage to sheer themselves, as it is termed, to the shore, dragging along with them a small rope from a coil lying on the deck of the steamboat. The newcomers who are waiting on the shore jump into the boat as fast as they can, pitching in before them their trunks and baggage. When all is ready, one of the seamen in the boat makes a signal to the steam vessel, which by this time has probably shot to some distance past the dock. As soon as the signal is seen, the end of the rope which is on board is passed around a roller moved by the machinery, and the boat,

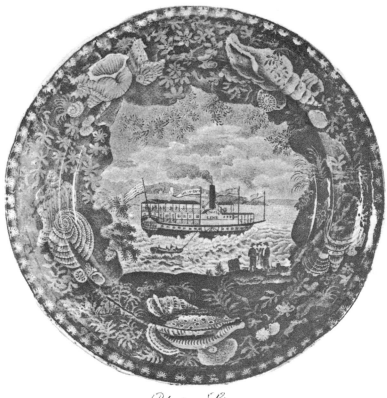

Union Line.

with her cargo of passengers, is drawn swiftly along-
side, and little or no time is lost. Regulations exist, I
understand, directing steam vessels to stop their en-
gines entirely while passengers are landed or taken on
board ; but as the high fever of competition is strong
upon them all, no captain wishes to lose one minute of
time, and therefore on such occasions the paddle-
wheels are merely slackened a little in their speed, and

179

the whole operation is performed with a rapidity by no means agreeable to nerves unaccustomed to fresh-water navigation."

The companion to this plate pictures a "Union Line" steamboat, whose appearance closely resembled the "Chief Justice Marshall." Yet careful comparison shows that the boats differed in the length of the bowsprits and character of the flags displayed; also the flagstaffs in the rear stand at a different angle.

This line had almost a monopoly of the passenger traffic between New York and Philadelphia. The boats left the foot of Cortlandt Street daily at eleven A. M., and landed their passengers at New Brunswick, whence they went by stage to Trenton, where they lodged for the night. Continuing their journey the next morning, they reached Philadelphia by boat at ten A. M.

The author just quoted writes of this journey as follows:

"In spite of the doctrine of liberty and equality, it is in vain to deny that these said grand steamboats carry at one moment many distinctions of rank—a circumstance which would matter little if the whole journey were made by water, because persons of different habits, when there is room for choice, naturally keep together. The steerage passengers leave the quarter-deck free to ladies, or to those who choose to pay some-

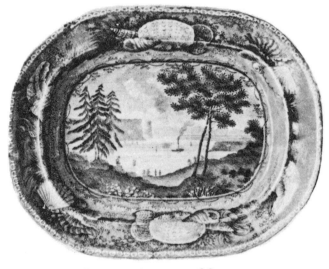

Tappan Zee from Greensburg.

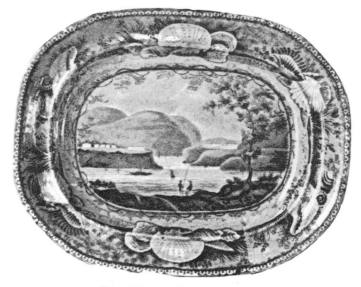

West Point Military Academy.

thing more for the honor and glory of the principal accommodation. But when the vessel stops, and a dozen or two of carriages dash down to the wharf each adapted to carry ten passengers, a scene of indiscriminate confusion and intermixture might occur, unless

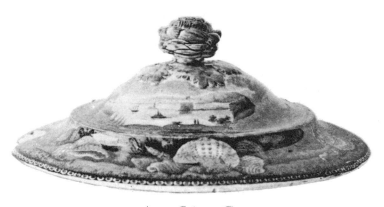

New York Bay.

steps were taken to preserve some classification of the company.

"The fitting arrangements to maintain order and prevent disagreeable propinquities without hurting the dignity of any one are accomplished by a simple enough contrivance. The captain of the boat goes about the decks during the voyage, and having taken down the names of all the passengers, he judges from appear-

ances what persons are likely to be agreeable coach companions to one another. He then tells each person what the number of the stage is in which it is destined he shall proceed after landing. The passenger, on learning his number, points out his luggage to one of the crew, who marks with a piece of chalk all the trunks and other things with the same number as the coach. Then the goods and chattels are sure to keep company with their owner, who, in fact, is treated pretty much as if he himself were a portmanteau and finds himself handed along from boat to coach, and from coach to boat again, with extremely little care on his own part."

The control of this line was in the hands of Colonel Stevens and his sons, whose home was pictured in the preceding chapter.

At the outset of his career the famous Commodore Vanderbilt was in command of the "Bellona," which belonged to this line.

Wood's views of the Hudson River and New York State are as follows:

1. "New York Bay," on the cover of a soup tureen (illustration, page 183).

2. "Tappan Zee," from Greensburgh (now Dobbs Ferry), on a small platter (illustration, page 181). A poorly executed view, yet undoubtedly chosen from

Pass in the Catskills.

Highlands, Hudson River.

the prominence given to Greensburgh at about the time this sketch was made, for here it was that Isaac Van Wart, one of the captors of Major André, was buried in 1828. His funeral was almost national in character.

3. "Highlands, Hudson River" (on page 185). An early print convinces me that the vessel shown on this platter is the famous "Chancellor Livingston," the "skimmer of the river," under full sail and steam. This boat was built in New York in 1816 by Henry Eckford and for some years was the largest and handsomest passenger steamboat in the world. Her length was one hundred and sixty-five feet and her beam fifty. Her boilers were of eighty horse power and weighed twenty tons : at times with wind and tide favoring she made fifteen miles an hour. Accommodations were afforded for two hundred passengers. The ladies' cabin was on deck, while the dining-room and men's cabins were below.

4. "Highlands at West Point " (see page 35). A six-inch plate which awakens memories of Washington and Lafayette, and Arnold and André.

5. "Military Academy at West Point," on a small platter ; a poorly executed print (see page 182), showing the stone buildings of this famous military school which was started in 1802 by the Colonel Jonathan Williams previously referred to.

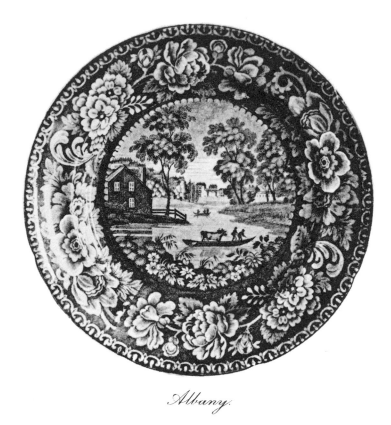

Albany.

6. "Hudson River near Newburgh" (illustration, page 33). A coarsely printed six-inch plate picturing the heights along the Hudson River near Newburgh which village is inseparably connected with the Revolutionary Army, for there it was that the Order of the Cincinnati was formed.

7. "Catskill Mountains and Hudson River," on a small platter (illustration, page 42).

8. "Hope Mill, Catskill, N. Y." (illustration, page

176). This scene, on the base of a soup tureen, pictures the Catskill Creek and the Hope Mill in the hamlet of Jefferson, on the outskirts of the town of Catskill. This was one of the oldest paper mills in the country.

9. "Pine Orchard House, Catskill Mountains," on plates (illustration, page 47). A favorite resort for travelers from every part of the country.

10. "Pass in the Catskills." This is found on small plates and the bases of gravy tureens (illustration, page 185).

11. "City of Albany," from the opposite shore, on a ten-inch plate (illustration, page 68). One of the richest of the dark blue plates, and giving a view of the city from the opposite shore. Upon the hill the capitol can be plainly distinguished.

12. "Albany " (from Rensselaer's Island), on a ten-inch plate (illustration, page 188). The print from which this was taken appeared in Hinton's " History of the United States," published in 1830; and dates this peculiar flower border series of views of our cities as being made not earlier than that year. This plate is probably one of the last dark blue pieces made by Wood.*

* While examining pieces with this border, I have failed to find the maker's mark on the back; yet many features in the decoration of these plates point to their being the work of E. Wood & Sons.

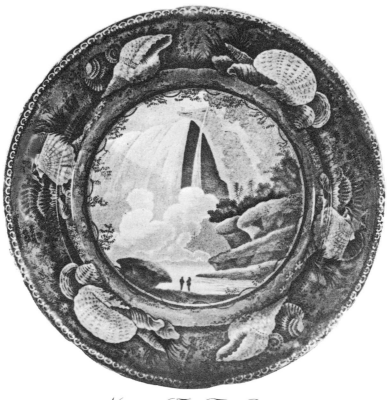

Niagara Falls. Table Rock.

13. "Near Fishkill" (see page 177).

14. "Hobart Town." On this plate appears a view of a small settlement on the Delaware River, near its source.

Other New York State views made by E. Wood & Sons are:

15. "A View of Lake George," on a large platter.

16. "Commodore Macdonough's Victory" on Lake Champlain, on various pieces.

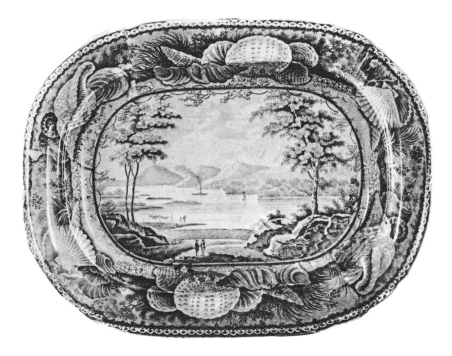

Lake George.

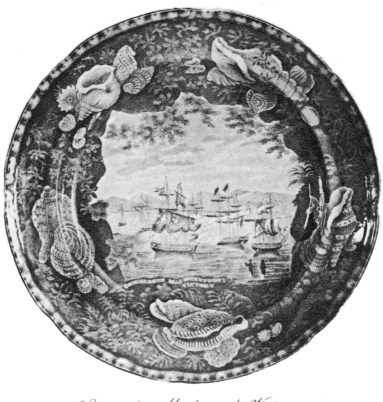

Commodore Macdonough's Victory

The central portion of a large folio engraving by Tanner of a painting by Reinagle furnished the subject which was most freely used by Wood for plates of different sizes and hollow ware of various descriptions. Its popularity was undoubtedly caused by the fact that September 14th, 1814, not only witnessed one of the most glorious victories achieved by the American navy, but also saw New York State saved from the threatened attack of the British veterans, fresh from their

triumphs over Napoleon. An invasion from Canada was planned, which had for its end the capture of New York. The projected route followed the road chosen by the ill-fated Burgoyne. The command of Lake Champlain was necessary to this undertaking. The American squadron, hurriedly built and fitted out by a young lieutenant named Macdonough, awaited the British fleet at Plattsburgh in a most skilfully selected position, and, although overmatched in size as well as in strength of armament, gained a most decisive victory over the veteran Captain Downie and his fleet. The same evening the British army, composed of men who were known from their acts on the Peninsula to be as brutal as they were brave, most ignominiously retreated, and New York was spared from the sufferings of a hostile invasion.

In the view shown can be seen the British frigate " Confiance " and brig " Linnet," with sails half furled, attacking the flagship of Macdonough, the little " Saratoga," and the brig " Eagle," which at anchor awaited their coming. The range was close for modern times. The entire weight of metal thrown at a broadside by the whole squadron was less than that of a single shell hurled from one of the twelve-inch guns of one of our modern battleships, and the heaviest charge of powder used in either fleet did not exceed six pounds.

17. "Trenton Falls," a favorite resort near Utica.

Here the West Canada Creek, flowing through a chasm nearly four miles long, formed a series of cascades and waterfalls startling in their grandeur. A well-kept hotel near the falls furnished accommodation to the visitor.

18. "Niagara Falls, Table Rock," appears upon dinner and soup plates, as well as bowls (see page 190).

19. "Niagara Falls, from the American Side," is found upon medium-sized platters (see page 80).

Stevenson also made a view of "Niagara" from the Canadian side (illustration, page 39). This print was also used in the Erie Canal series, for upon the border of one of these are found the four medallion portraits and the canal at Albany, previously alluded to.

This chapter would not be complete without attention being called to a large dinner plate bearing the coat-of-arms of New York State. This was part of a set decorated with the coat-of-arms of the original thirteen States, and made by T. Mayer at Stoke.

A large folio copy of the Declaration of Independence, published in Philadelphia in 1818, supplied this potter with these subjects. The workmanship upon this engraving was most elaborate. The correctness of the signatures was certified to by John Quincy Adams. In oval frames surrounding the document

were illustrations of the coats-of-arms of the original
States, which were furnished by Thomas Sully, the
well-known artist. The coat-of-arms, or seal of the
State of New York, was designed and adopted in 1778.
After various alterations the exact design, shown upon
the plate, was first put in use in 1807.

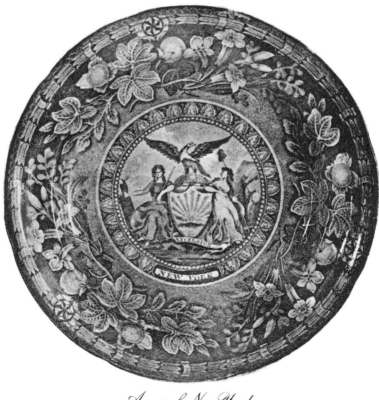

Arms of New York.

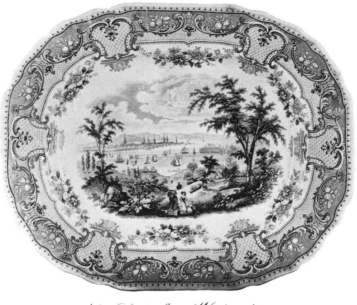

New York from Weehawken.

NEW YORK FIRE OF 1835

FROM 1820 to 1830 great improvements were made in the quality of the earthenware with which Staffordshire supplied the foreign markets.

About the year 1828 another style of ornamentation of table ware was introduced, which in a few years speedily superseded the beautiful dark blue pottery described in the former pages. This change was remarked upon in 1829 by a

writer who noted: "Manufacturers using red, brown and green colors, for beautiful designs of flowers and landscapes; on pottery greatly improved in quality, and shapes formed with additional taste and elegance. This pottery has a rich and delicate appearance, and owing to the blue printed having become so common, the other is now obtaining a decided preference in most genteel circles."

In the latter part of 1830 appeared the first edition of the "History and Topography of the United States," by J. H. Hinton. The book was published in London and dedicated to Washington Irving. Its two volumes were full of illustrations. A few months after its publication the following advertisement appeared in the New York "Commercial Advertiser" of May 3rd, 1831:

"To Earthen Ware Dealers. A quantity of new patterns of Messrs. Job and John Jackson's Burslem Superior Ware, comprising some very elegant American views, also a variety of Tea Ware patterns, etc., received by the last ships, and may be seen at 138 Pearl Street, where orders are taken for same by

"Sherman & Gillin."

The engraving on these pieces was of the highest order. Three of the illustrations of views in New York City furnished subjects to the Messrs. Jackson, viz.:

1. "The Battery."

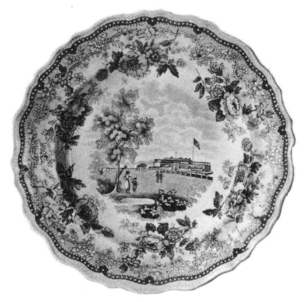

The Battery.

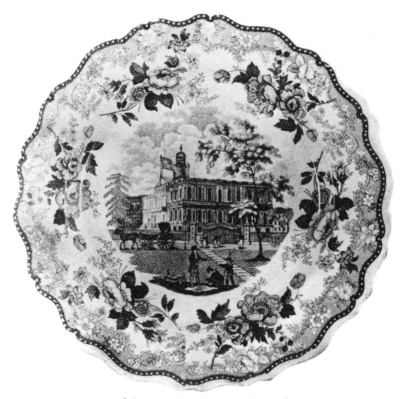

City Hall New York.

2. "New York from Weehawken." (See head of chapter.)

3. "New York City Hall."

The date of the ware is fixed by the advertisement quoted.

Among later pieces made by Clews was a large platter with a view of New York from the harbor, copied from one of W. G. Wall's designs (illustration, page 205).

E. Wood & Sons used a view of the Battery to cover the sides of a large soup tureen (illustration, page 197).

Another and a far-reaching change then took place in the process of decoration of the cheaper form of pottery. Competition at the time was most keen, and, unfortunately for the beauty of the potter's art, lithography was adopted as a less costly method of printing upon earthenware. The impossibility of preparing the stone to hold more than a slight amount of color resulted in great weakness of tint. The new method of decoration was so economical that it was soon used for all the cheaper classes of earthenware, and just as the rich copper-plate engravings uniformly used for illustrations in the early part of this century were forced out by the coarse etchings on stone, so the beautiful deep blue of the potters was superseded by the lighter

colors. Since that time hundreds of views illustrating American history have appeared upon pottery.

Among these, in workmanship and historical interest, the three New York Fire plates are pre-eminent, commemorating, as they do, the great disaster which laid New York City prostrate for a time. The year of 1835 opened most hopefully for New York. The tremendous trade brought to the city through the Erie Canal had greatly stimulated business, and an excited speculation in real estate, which in many cases had quadrupled the value of property, was in full blast.

On the night of December 16th a great fire broke out in the lower part of the city, and before its progress was arrested devoured in its flames nearly seven hundred buildings and sixteen millions of dollars' worth of property. A few days after the conflagration three large lithographs, sketched and drawn upon stone by J. H. Bufford, and published jointly by the artist and J. Disturnell, found a ready sale. A set of these three pictures were transferred to earthenware. Stone was used in the printing instead of the copper-plate, with the result that, though the drawing was well executed, the coloring was weak, and the plates have none of the warmth and depth of tone seen on those decorated by the old-fashioned process.

The first of these was entitled the " Burning of the

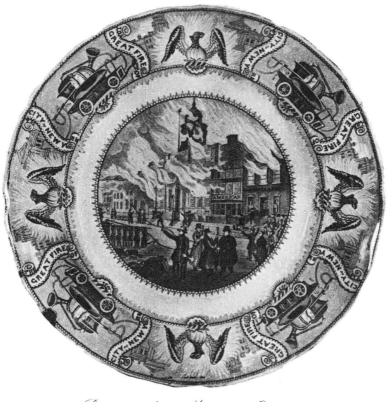

Burning of the Merchants' Exchange.

Merchants' Exchange" (here shown). This building occupied the site in Wall Street where the Custom House now stands. Erected in 1825 by a number of merchants, who recognized the need of a building where the business men of the city could congregate to make their transactions, its white marble walls and Grecian architecture made it the handsomest edifice in the city.

Here it was that the auction sales of merchandise

and real estate were held, and a large room on the second floor was devoted to the use of the body of men who dealt in securities. The Chamber of Commerce held its meetings here, and the basement furnished commodious quarters for the Post Office. Various insurance companies occupied rooms on the lower story. It was the centre of the city's business activity.

To the right of the Exchange was the office of the "New York American," an evening paper edited by Charles King and subscribed to by the best people of the city.

Adjoining this building the home of the Fulton Fire Insurance Company was situated. The type of building shown in the illustration was commonly erected for dwelling-houses, for Wall Street had not yet been entirely devoted to business, and many a merchant prince and banker still lived with his family in quarters over the room in which he was accumulating a fortune.

The evening of December 16th was a terrible one. A fierce gale was blowing, the thermometer registered ten degrees below zero, and the hydrants were frozen. An attempt was made to pump water from the East River, but this was unavailing, as the water froze in the leather hose pipe long before it reached the puny little engines of the Fire Department.

In the foreground, to the left, may be seen a com-

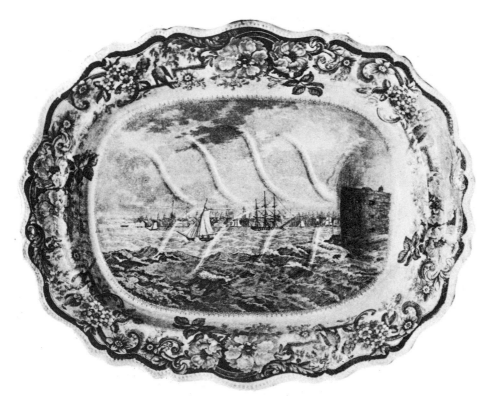

New York, from the Bay.

pany of firemen working at the brakes of Engine No. 13, a picture of which appears on the border of the plate. The officials of the city are seen in the centre. The group consists of James Gulick, the chief engineer, dressed in his fireman's uniform and holding in his hand a fireman's trumpet. Behind him stands Jacob Hays, who so long and honorably held the position of Chief of Police, and who, from his astuteness in detective work, was popularly known as the "thief taker," and John Hillyer, the Sheriff, with his staff, the insignia of his office, facing the Mayor, Cornelius W. Lawrence. The gentlemen were all wrapped in greatcoats and capes. Their faces are all clean-shaven, for at this time it was the universal opinion that no man could be honest who would wish to hide his upper lip, and fashion frowned upon those Americans coming from abroad who attempted to introduce into the Knickerbocker city the moustaches and goatees worn in Europe.

The next plate of this series pictures the "Ruins of the Merchants' Exchange," with a detail of the National Guard (now the Seventh Regiment) patrolling the streets of the city in their full uniform of tall hats and long-tailed coats (illustration, page 208).

A tea plate in this set bears a picture of the "Burning of Coenties Slip," and shows the river filled with ice and floating packages of merchandise ; also the

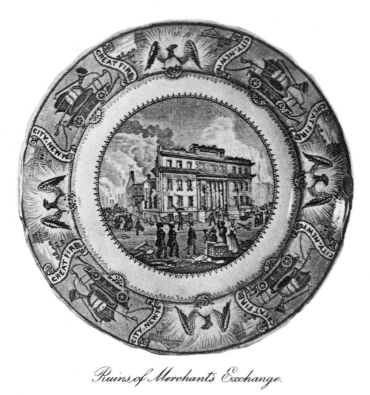

Ruins of Merchants' Exchange.

warehouses on the bank from which the flames are
bursting forth.

The progress of the fire was finally checked by the
heroic remedy of blasting with gunpowder houses and
stores in the path of the flames.

The distress caused by the conflagration was far-
reaching. The insurance companies, with few excep-
tions, were rendered bankrupt, and many persons who
had invested in these corporations became penniless.
Still, such was the indomitable energy of the people

that, instead of wasting time in idle lamentation, they commenced to rebuild the burnt district almost before the ruins ceased to smoke, and only a few months elapsed before fine buildings covered the sites of those destroyed by the great fire of 1835.

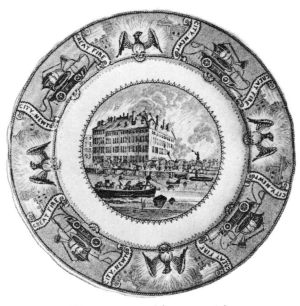

Burning of Coenties Slip.

PICTURES OF
BOSTON AND NEW ENGLAND

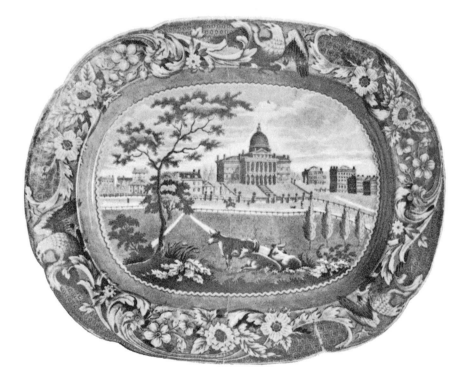

State House, Boston.

Court House, Boston.

BOSTON AND NEW ENGLAND

THE dark blue pottery of Staffordshire perpetuates many New England scenes. Among these, in times past, none were more popular than the views of the Boston State House and Common. The latter is inseparably connected with the history of the city.

In 1634 the Town Fathers, with great foresight, purchased forty-four acres from William Blackstone,

Boston's first settler. This plot was set apart for a pasturage and also as a military training-ground. It also served as a place of execution for criminals until 1812. The fanatical Puritans used it as a spot for venting their spleen upon such of their number as were accused of witchcraft. It was also the scene of the torturing and hanging of the Quakers. These were not the simple unoffending people who have made the term Quaker a synonym of gentleness, but a sect that persisted in flouting its tenets in defiance of all established law and custom. In 1745 the Common was the mustering-place for the Colonial troops, prior to their successful attack upon Louisburg. Ten years later the New England contingent used it as a drilling-ground during the seven long weary months spent in awaiting the arrival from England of the promised arms which were to be used in the expedition against Canada. In 1768 the joyful celebration over the repeal of the Stamp Act was held here. The assembling of the British troops on this ground on the evening of the 16th of April, 1775, warned Dr. Samuel Warren and Paul Revere of the expedition against Concord and Lexington. On June 17th, 1775, this spot held the British troops drawn up in review just prior to their assault upon Bunker Hill. A few days later it was used as a burial-ground for the many victims of the deadly fire of the American rifle-

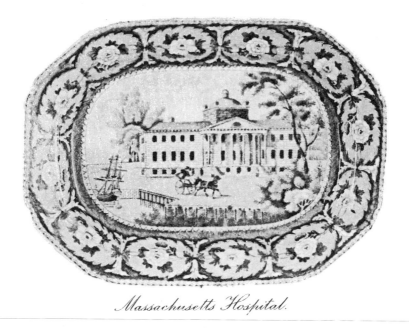

Massachusetts Hospital.

men. The Common then was heavily fortified against the threatened attack upon the city. Upon the evacuation of Boston by Lord Howe it became the parade-ground for the Continental troops. In 1830, owing to some serious accidents, the peaceful cows which appear in the illustration were no longer allowed to pasture within this enclosure.

Facing the Common is seen the Boston State House. The corner-stone of this famous building was laid July 4th, 1795, by the Governor, Samuel Adams, assisted by Paul Revere as Masonic Grand Master. The ground for it was purchased from the heirs of John

Hancock. The plans chosen were made by Charles Bulfinch, the famous architect. The original cost was $133,000. Great economy was exercised in the selection of materials. The walls were of brick ; the columns in front were made from trees grown upon the land of Edward H. Robbins, Speaker of the Assembly ; its famous dome was painted yellow, and its walls were colored in imitation of the Portland stone commonly used. The building originally measured one hundred and seventy-three by sixty-one feet. In 1853 its depth was increased.

To the extreme left is the house erected in 1804 by John Phillips, the first Mayor of Boston and the father of Wendell Phillips. At the time this pottery was made it was occupied by Thomas L. Winthrop, the father of the Hon. Robert L. Winthrop. The adjoining building I have not been able to identify definitely. To the right of this is the residence of Dr. John Joy. Overtopping his house appears the home of Thomas Perkins, which faced Mount Vernon Place.

Between this group of dwellings and the State House can be seen the fine old Hancock mansion. This view of it is unique, as it shows the wooden extension added to the northern end to afford space for the lavish entertainments given by the owner. The house was built by Thomas Hancock in 1737, and was given to

John Hancock by his aunt, Lydia Hancock, the wife of the original owner. Owing to the prominent part taken by Hancock during the stirring scenes before the Revolution, the house was pillaged by the British soldiers at the time of the Battle of Lexington.

Among the distinguished guests entertained there were D'Estaing, Lafayette and Washington. In 1859 the house was offered to the Commonwealth at a moderate cost. Great efforts were made to secure the passage of a law which would preserve it, but in vain. In 1863 this historic dwelling was pulled down.

To the right of the State House is the splendid home of Joseph Coolidge. Charles Bulfinch considered this the finest private dwelling erected under his supervision.

The tall house below this was the home of Thomas Amory, built by him in the latter part of the last century. It stood on the corner of Park and Beacon Streets. At a later date it was divided into four dwellings. Among those who lived there at various times may be mentioned George Ticknor, the distinguished scholar ; Malbone, the miniature painter, and Samuel Dexter, a great lawyer and statesman. During Lafayette's visit to the city, in 1825, the entire house was rented by the Mayor for the accommodation of the city's guest. The last house to the right is that known as the Gore house,

where Governor Christopher Gore resided for many years. Between this and the Amory house appears the residence of Josiah Quincy, Jr. It is needless to say that of all these stately mansions, erected before

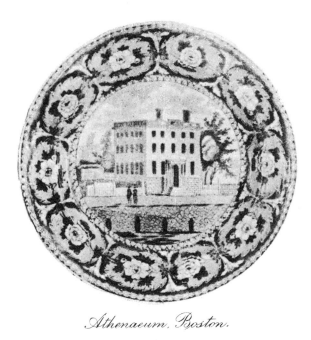

Athenaeum, Boston.

or at about the beginning of this century, not one remains.

The date of the sketch just described can safely be ascribed to the period 1820–30. The fence inclosing Beacon Mall, put up in 1820, defines it as not made

prior to that date, while the presence of the cows on the Common, which were not tolerated after 1830, shows that the scene was not drawn after that year.

Five other views of the State House were printed upon this Staffordshire pottery ; some pieces show the building alone ; others, the Common as well.

Among the great public buildings of Boston perpetuated by the potter we will describe :

1. The old Suffolk County "Court House," two views of which appear at the head of this chapter.

This was erected in 1810 upon a site which tradition says was the home of Isaac Johnson, Boston's early settler, and was constructed of hammered white stone, after plans designed by Bulfinch. Its centre was octagonal, and the addition of two wings gave it a frontage of one hundred and forty feet. It cost nearly $93,000. While originally built for a Court House, it served for a City Hall as well, and furnished quarters for the Mayor and Common Council, the City Auditors and Marshal. It stood until 1862, when it was pulled down to make room for the new City Hall.

At the time this view was made the collections of the Columbian Museum were exhibited in the small building to the left of the Court House.

2. "Boston Athenæum."

This institution was incorporated in 1807. In 1822

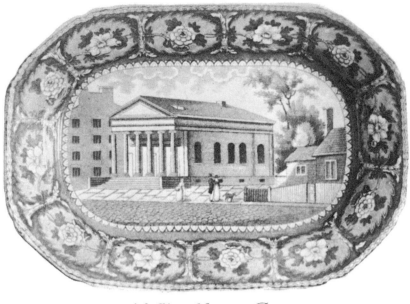

St. Paul's Church, Boston.

it moved into the square building shown in the illustration, page 218. It stood on Pearl, corner of High Street, and was secured through the liberality of James Perkins, who presented half the cost of the building to the Society. At the time of its removal to its new home the Library contained seventeen thousand four hundred volumes and ten thousand pamphlets. In 1849 the Library was moved to its present quarters on Beacon Street.

3. "St. Paul's Church."

This still stands on Common Street, between Winter and West Streets. Its corner-stone was laid in

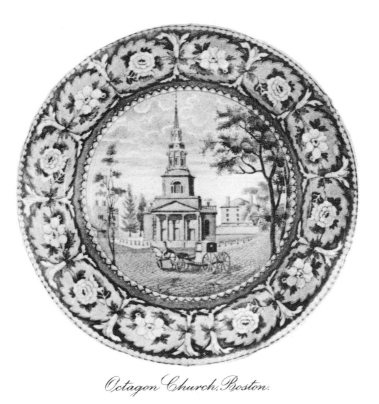

Octagon Church, Boston.

1819. The consecration took place the next year. The front presented a simple Ionic hexastyle portico with columns of freestone. The original plans called for the filling in of the pediment with a bas-relief picturing Paul before Agrippa. Lack of funds left this space unfilled. Beneath the floor were tombs, one of which held for many years the remains of General Warren, who lost his life at Bunker Hill.

4. "Octagon Church."

The New Old South Church, the most beautiful

church in Boston, stood on Church Green, at the inter-
section of Summer and Bedford Streets, from 1814 to
1868. Its site was granted for a church by the town to
a number of petitioners as far back as 1715. The archi-
tect was Bulfinch. Its walls were built of hammered
granite. From its octagonal ground plan it was desig-
nated as the Octagon Church, which name appears on
the back of the plate illustrated. The building was
topped by a tall spire, and its front was ornamented
with a portico of free-standing columns. In the back-
ground, to the right of the church, is pictured the resi-
dence of Nathaniel Goddard, an old-time Boston mer-
chant. This house stood on the corner of Kingston
and Summer Streets, and was erected in 1809. On the
other side of the church appears the house of James H.
Foster, a deacon in the New Old South Church and a
well-known merchant. Mr. Foster lived here from
1809 until 1860. Bedford Street, at the time this pot-
tery was made, was known as Pond Street, deriving its
name from the large pond near Washington Street.

5. "Alms House" (illustration, page 239).

The edifice, which is found on pitchers and plat-
ters, stood, from 1800 to 1825, on Leverett Street, on the
bank of the Charles River. Brick and marble were the
materials used in its walls. The dimensions of the build-
ing were two hundred and seventy by fifty-six feet.

6. "Boston Insane Hospital" (illustration, page 237).

Upon this plate appears the residence of Joseph Barrell, a wealthy Boston merchant. This house was one of the earliest designed by Charles Bulfinch, then (1792) at the very outset of his career. These two gentlemen, with four others, owned and fitted out the ships "Columbia" and "Lady Washington." Their expedition discovered Oregon and the Columbia River, and gave the nation a clear title to the States of Oregon and Washington. The estate of Mr. Barrell was renowned for its beautiful gardens and rare plants. In 1818 it was purchased by the Massachusetts General Hospital Corporation. Wings were added to the house, which was then turned into a home for the insane. In recognition of the generous contributions of John McLean, the name McLean Hospital was given to the institution.

7. "Massachusetts Hospital" (illustration, page 215).

The corner-stone of the Massachusetts General Hospital was laid in 1818. The hospital was opened three years later. The material used was Chelmsford granite, hammered by the convicts in Charlestown. Its dimensions were one hundred and sixty-eight by fifty-four feet. On its front part was a portico with eight Ionic columns.

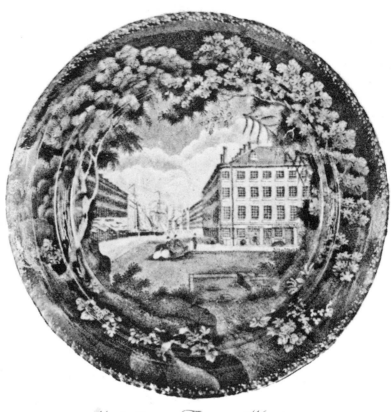

Mitchell and Freeman's Warehouse.

8. "Mitchell and Freeman's China and Glass Warehouse."

This plate gives us a view of Chatham Street, with the shipping in the upper harbor in the distance. It was evidently ordered by the above-mentioned firm, who occupied No. 12 Chatham Street from 1828 to 1832. A beautiful border of trees and foliage surrounds this view.

Across the Charles River, in the old town of Cambridge, stands Harvard College, inseparably connected with the history of New England from its earliest days. In the faculty room in University Hall hang two paintings made by Alvan Fisher in 1821. Portions of these two pictures were carefully copied, and furnish central decorations for three of the dark blue plates with acorn borders. The great exactness with which the persons, horses and dogs in the foreground are reproduced on the pottery inclines me to the belief that the sketches sent over to Staffordshire were made by Fisher himself (illustrations, pages 226-7).

On the largest of these plates, to the right of the college buildings, appears Christ Church. This owed its existence to the " Society for the Propagation of the Gospel in Foreign Parts," which in 1761 supplied the funds for its erection. During the siege of Boston the church was turned into a barracks by the American troops, though tradition tells us that Mrs. Washington was wont to attend divine service there. After the war, its original congregation having been dispersed, it remained unused until 1791, when services were resumed, and they have been continued to this day.

To the left are seen four famous old buildings— Holworthy, Stoughton, Hollis and Harvard Halls—all perpetuating honored names. Of these, Holworthy

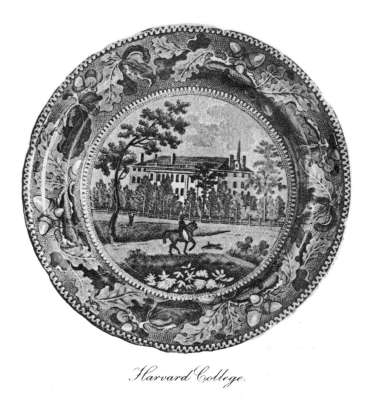

Harvard College.

and Stoughton were erected in 1812 and 1804, respectively, from the proceeds of lotteries authorized by the General Court of Massachusetts, while Hollis (1763) and Harvard (1766) were built from funds contributed directly by the General Court of the Province.

The above plate bears a view of University Hall. Built of white granite in 1815, it was considered one of Charles Bulfinch's masterpieces. In the distance is seen the spire of the old meeting-house, where, from the time of its erection in 1761 until the building of University Hall, the students attended services. The com-

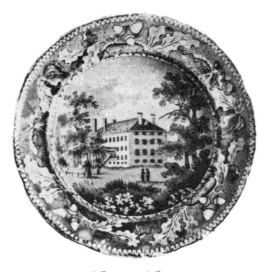

Harvard College.

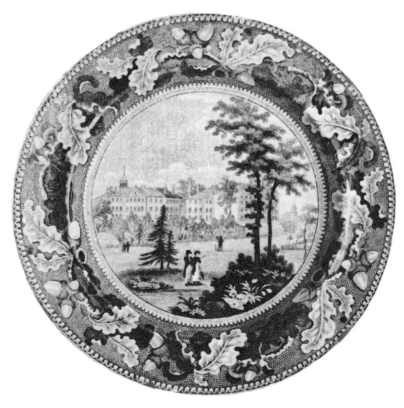

Harvard College.

mencements were held and the presidents of the college were inaugurated here. Within its walls the Constitution of Massachusetts was framed in 1779 by delegates from the different towns of the Province.

The third view of this series shows another side of University Hall.

A strong reminder of Boston's part in the Revolution is found on a platter marked the "Battle of Bunker Hill" (illustration, page 22).

This is the piece most sought after by all collectors of Staffordshire pottery. Certainly it shows a realistic picture of the battle, where the British officers first learned that the raw Colonial militia could withstand the royal forces in support of the cause for which they enlisted. Few battles, if any, have been won by such unparalleled bravery as was displayed on this occasion by the British veterans, who, twice repulsed by the deadly marksmanship of their opponents, with almost a third of their comrades killed or wounded, returned to the charge and, trusting to the bayonet alone, steadily mounted the hill for the third time and carried the redoubt. Whether such superb courage would have been successful had ammunition not failed their adversaries, must remain unanswered.

The scene pictured by Stevenson shows the redoubt upon the hill, the hillside strewn with the dead

and wounded, the English troops, with officers leading, drums beating and colors flying, mounting to the attack. Beyond the hill appear the flames of burning Charlestown; to the left are two men-of-war, assisting

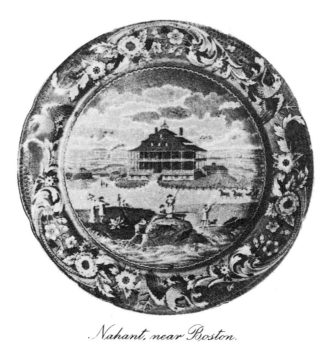

Nahant, near Boston.

in the attack, while in the distance are seen the church spires of Boston.

The early days of Nahant, now one of the most popular watering-resorts near Boston, furnished two potters with views for the decoration of their wares.

The Hon. Thomas H. Perkins, of Boston, became attracted to this place, which hitherto had been a

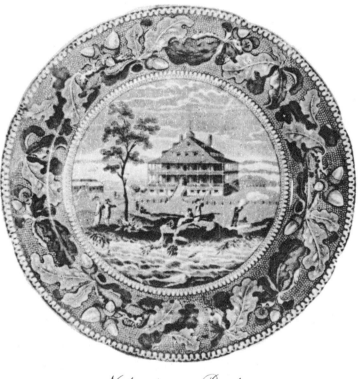

Nahant near Boston.

famous shooting-ground. Recognizing its advantages for a summer resort, he built in 1817 the first cottage there. His example was quickly followed by others.

231

The hotel shown in the illustrations was erected in 1820 by a company of gentlemen, among whom were Mr. Perkins and Dr. Edward H. Robbins. Its stone walls, surrounded by wooden verandas, enclosed one hundred rooms. In the foreground of the view may be seen people fishing and shooting; to the right a cabriolet appears, while to the left, on the water, is a small steamer, the "Eagle," which made daily trips to Boston. A print in Snow's "History of Boston" (1825) supplied Stubbs with this scene.

The two acorn border plates of Stevenson show the same view of the hotel with different surroundings.

The Landing of the Pilgrim Fathers is always a scene which appeals to the numerous descendants of this little band who came over in the "Mayflower." A quaint representation of this event found ready sale, especially in New England.

The centre of these plates shows the "Mayflower" in the offing, with her small boat landing some of her immortal human cargo. Two Indians are interested spectators. The rock upon which they stand bears the names "Carver," "Bradford," "Winslow" and "Standish." On the border are four medallions:

1. "America Independent, July 4th, 1776."
2. "Washington, born 1732. Died 1799."
3. The victory of the "Enterprise" over the "Boxer."

Landing of the Pilgrims.

4. One of the early steam vessels, and an American eagle in exultant attitude on the shore.

An equally popular series of plates, platters and vegetable dishes pictures "A Winter View of Pittsfield" (Massachusetts).*

The most conspicuous of the buildings which ap-

* The illustration fails to do justice to this beautiful plate. The extraordinary brilliancy of the glaze upon the convex centre causes such reflections that it is impossible to satisfactorily reproduce this subject by photography.

pear on this plate is the First Congregational Church, the funds for which were raised by an assessment upon the town people ; for the union of Church and State, which the Puritans left England to escape, was close in many a New England town. The church was erected in 1793. Bulfinch was its architect. In 1853, after being slightly damaged by fire, it was moved to the grounds of the Maplewood Academy, where, bereft of its spire, it was fitted up as a gymnasium. To the right of it is seen the old Town Hall, where, from 1793 for nearly forty years, the town meetings were held. In its lower rooms the public school had its quarters. The First Baptist Church is also pictured. Its site was the old burial-ground, which was donated by the Town Fathers. The structure was finished in 1827. The introduction of this building into the view dates the making of these plates as between 1827–1830, for in the latter year the maker, Clews, retired from business. To the extreme left we see the Berkshire Hotel, which until 1866 entertained many travelers. This was built in 1826.

Prominent in the foreground stands the famous Pittsfield Elm, well known for its size and beauty, and which figures in all early views of this typical New England town. To the sorrow of the residents in the neighborhood, this stately landmark was killed by a stroke of lightning, but it remained standing for some

Winter View of Pittsfield.

years until it was pulled down in 1861. Its wood formed many a precious memento of the former grandeur of Pittsfield's great elm. The elliptical fence enclosing part of the Common was put up in 1820 for the purpose of carefully guarding this tree.

One other New England town, Hartford, furnished the potters with two subjects, one of which, the "State House," appeared on various pieces of a coffee set.

The building was of brick. Erected in 1796, it was the seat of the State Government until 1879 ; since then it has been used for a City Hall.

The other, the " Deaf and Dumb Asylum," has a most interesting history. In 1815 a number of gentlemen of this town, recognizing that this country afforded no place where the deaf and dumb could have their condition ameliorated and their lives brightened, sent a young theologian, Thomas H. Gallaudet, to Paris to study under the celebrated Abbé Sicard. After a two years' course of instruction Mr. Gallaudet returned home, bringing with him a fellow-pupil, Laurent Clerc, a deaf-mute. Immediately upon their arrival at Hartford they opened the first school in this country for the instruction of the deaf and dumb. Its quarters were in a room in the present City Hotel. Its pupils numbered seven. The next year found sixty names on its rolls. Congress was appealed to for help to enlarge the scope of this already widely known institution. The response was a grant of 23,000 acres of land. In 1821 the building shown in the illustration was erected, and it still forms a part of the "American Asylum for the Education and Instruction of Deaf and Dumb Persons."

A tea set gives us still another view of New England, showing " Wadsworth Tower," in the town of Avon, near Hartford.

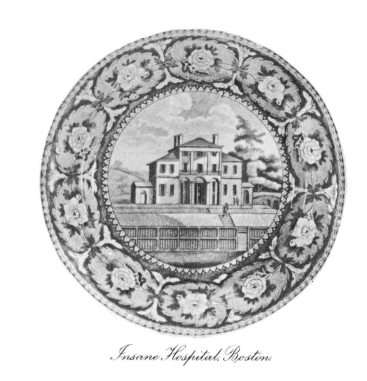

Insane Hospital, Boston.

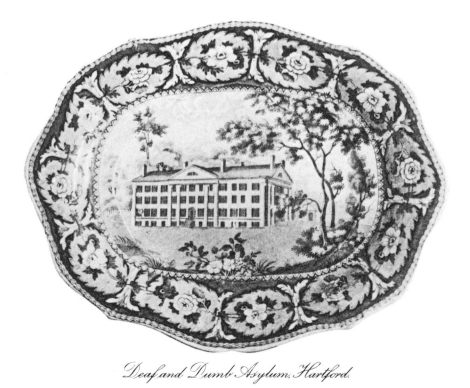

Deaf and Dumb Asylum, Hartford.

This was built in 1810 by William Wadsworth, and, until blown down in 1840, afforded a superb view of the Connecticut Valley. The observatory was a favorite spot for those appreciative of the beauties of nature. Few persons traveling in the vicinity failed to visit this place.

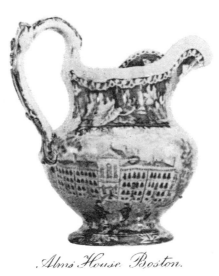

Alms House Boston.

PHILADELPHIA, THE SOUTH
AND WEST

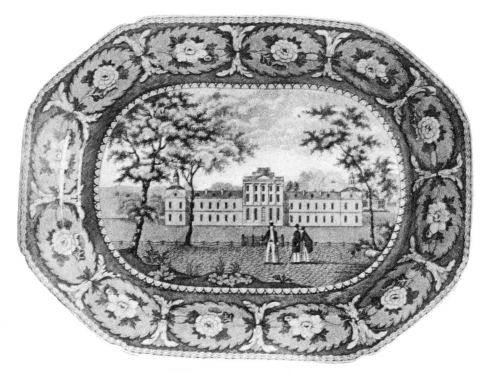

Pennsylvania Hospital.

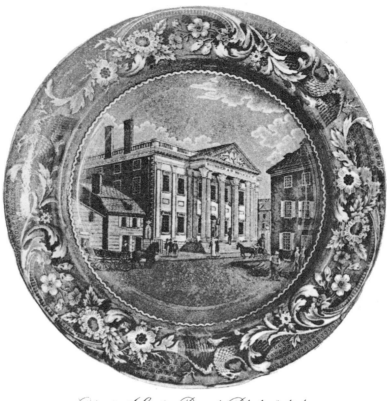

United States Bank, Philadelphia.

PHILADELPHIA, THE SOUTH AND WEST

A FITTING introduction to Philadelphia scenes is a plate showing the city in the distance and in the foreground the splendid Penn Treaty Elm.

Only six of the historic buildings of Philadelphia appear upon this pottery. The surrounding country, however, fur-

nished a number of designs, which proved most attractive and largely helped the sale of the ware which they decorated.

The list of Philadelphia views includes :

1. "United States Bank."

The National Government erected this white marble building in 1795 for the main office of the Bank of the United States, branches of which were established in the large cities throughout the country. The charter of this institution was granted in 1791. Politics interfered greatly with the bank's success. In 1811 its friends, after a fierce struggle, failed to secure a renewal of its charter. The next year Stephen Girard purchased the building for one-third of its original cost and started the Girard Bank, with a capital of $1,200,000. The principal deposits were retained, as well as the cashier. During the War of 1812, upon the failure of the Government to place but $20,000 of a $5,000,000 loan, Mr. Girard took the balance himself. Although the building on this plate is generally thought to be the United States Bank, yet at the time the plate was made the bank was owned by Stephen Girard, who dying in 1831, left his fortune to philanthropic institutions.

An engraving by Birch, published in 1799 and reproduced in the atlas of Axel Klinkowström (Stockholm, 1824), supplied this view.

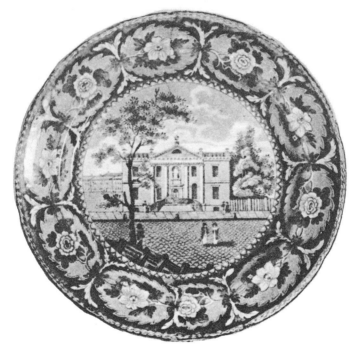

Library, Philadelphia.

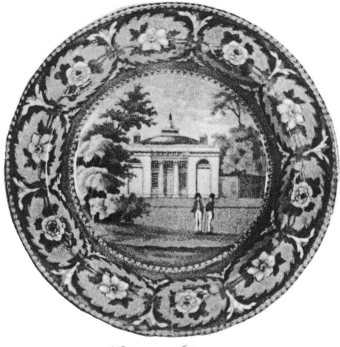

Staughton's Church.

2. "Philadelphia Library."

A small brick building situated on Fifth Street below Chestnut Street. This library was started in 1731, largely through the efforts of Franklin. In 1791 the books were moved to the building pictured on the plate. A statue of Franklin stood over the doorway.

3. "Pennsylvania Hospital" (see page 242).

This great institution also owes its origin largely to the assistance given to Dr. Thomas Bond by Franklin. In 1751 its home was a house in Market Street. In 1755 the east wing of the building, reproduced upon the platter, was erected ; the west wing was added in 1796, and the central portion in 1804. The situation chosen was the square bounded by Eighth, Ninth, Spruce and Pine Streets. Its first military occupants were the wounded Hessians captured at the Battle of Trenton.

4. "Staughton's Church."

This stood on Sampson Street, between Eighth and Ninth Streets. Its appearance was striking. The walls were fifty feet high. The rotunda, ninety feet in diameter, contained seats for twenty-five hundred people. The church was built for the Rev. William Staughton in 1811. This eloquent Baptist clergyman so stamped his personality on the building that it retained the name Staughton's Church long after his resignation in 1823.

5. "United States Hotel" (illustration, page 292).

This faced the United States Bank on Chestnut Street. John Rea was the owner. Two dwelling-houses standing upon separate lots were connected and converted into a large building, which was opened as a hotel in 1826. Thirty years later the property was sold to the Bank of Pennsylvania.

6. "Water Works" (illustration, page 286).

This dome-shaped marble building, erected on Chestnut Street in 1799, was the central pumping station of the new water works.

7. "Dam and Water Works" (illustration, page 249).

The old water works furnishing an inadequate supply, a new plant was established in Fairmount Park in 1813. This view pictures the dam built across the river to furnish power to pump the water into a reservoir, from which the city derived its water supply. The quaint stern-wheel steamer on the Schuylkill is of the type long obsolete.

A drawing by Birch, engraved by Tanner and published in "The Stranger's Guide to Philadelphia" (1828), supplied the potter with this subject.

8. "Dam and Water Works."

A view identical to the above in all respects, save that the vessel on the river is propelled by wheels placed

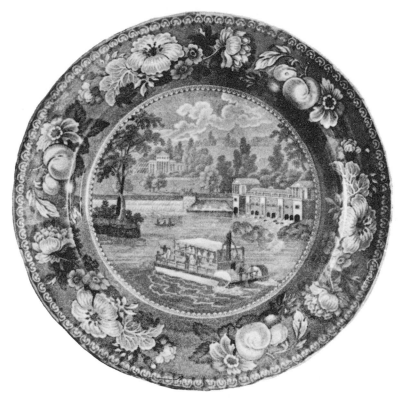

Dam and Water Works, Philadelphia.

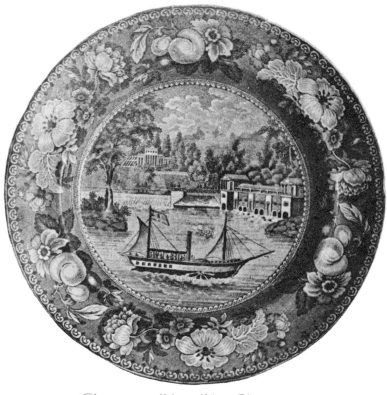

Dam and Water Works, Philadelphia.

on her sides. This vessel bears a striking resemblance
to the " Clermont," Fulton's first steamboat. The lat-
ter had the long narrow hull and two masts shown in
the illustration. The early pictures of the " Clermont,"
however, lack bowsprit and paddle-boxes. The boat
pictured on this plate was undoubtedly modeled after
the " Clermont."

Collectors of this Staffordshire pottery erroneously
insist on calling a handsome plate decorated with a view
of a short, broad steamboat, with a tall smokestack,
the " Fulton Steamboat plate." The surrounding scen-
ery, the absence of masts and shape of the hull, leave
little doubt that this unmarked specimen represents
some view in English waters.

9. " Fairmount near Philadelphia."

A view of Fairmount Park. On the Schuylkill ap-
pears a freight barge rowed by two men.

10. " Upper Ferry Bridge " (illustration, page 252).

This bridge was constructed in 1813 from plans by
Lewis Weinag. The chord of the arch measured three
hundred and forty-four feet, its rise was twenty feet,
and elevation over the water thirty feet. The tavern
near the bridge was kept by Richard Harding. The
scene is full of life. Along the river bank the artist has
drawn a covered emigrant wagon, a man on horseback,
a fisherman and a farm wagon. On the river is a freight

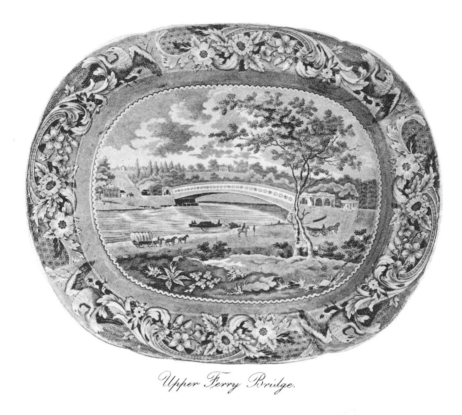

Upper Ferry Bridge.

barge. The atlas of Axel Klinkowstrôm (1824) sup-
plied this view to Stubbs.

11. "Mendenhall Ferry."

On the left of this plate is seen the Mendenhall
Inn. This stood on the west bank of the Schuylkill,
just below the falls. Opened in the early part of this
century, it was long a favorite dining resort for Phila-
delphians. One of the old-fashioned rope ferries crossed
the river here. In the distance are seen the country
houses of Joseph Sims and Dr. Physick.

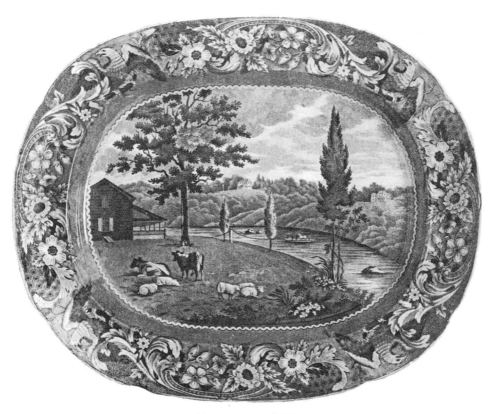

Mendenhall Ferry.

Stubbs obtained this view, as well as the one be-
low, from the " Series of Country Seats " published by
Birch in 1808.

 12. " Woodlands near Philadelphia."

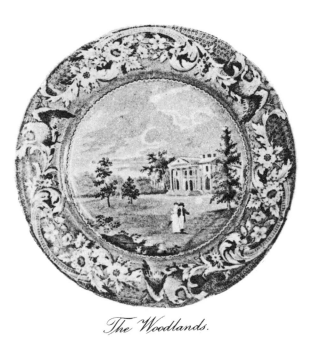

The Woodlands.

Its owner was William Hamilton, the son of the
Andrew Hamilton who so successfully defended John
Peter Zenger, the New York printer, in the trial which
established the liberty of the press in this country.

The house was built in Colonial days, and stood

on the banks of the Schuylkill, on the outskirts of Philadelphia. At the outbreak of the Revolution William Hamilton immediately raised a regiment for the Continental cause. His ardor soon cooling, he resigned from the service upon the signing of the Declaration of Independence. When the British troops left Philadelphia, Hamilton was arrested for treason and banished from the State. The ending of hostilities allowed him to return. His estate was famous for the beautiful gardens which surrounded the house, noted for its lavish furnishings and art treasures.

13. "View near Philadelphia."

A rare old print, engraved by James Smillie from a painting by Thomas Doughty, leads me to believe that this poorly printed plate bears a view of the Brandywine battle-ground, where Lord Howe, with an overwhelming force, drove Washington's army back and paved the way for the capture of Philadelphia.

14. "Gilpin's Mills on the Brandywine Creek."

This is the only dark blue ceramic Delaware view which has survived.

In the year 1750 Thomas Gilpin erected extensive mills on this stream near Wilmington. He married Julia Fisher, the daughter of a wealthy Quaker, and transferred his residence to Philadelphia. Being a man of scientific tastes, and becoming imbued with Quaker

Gilpin's Mills.

Near Philadelphia.

Baltimore Exchange.

tenets, he took no part in the Revolution, though two of his brothers were officers in the Continental army. In 1777 he, with a number of Quakers, was arrested for treason by the Americans and banished to Virginia, where nine months later he died. His mills descended to his sons, Joshua and Thomas. In 1787 the sons erected extensive paper mills on their property on the Brandywine, where for fifty years paper of the highest grade was manufactured. In 1816 Thomas Gilpin in-

vented and introduced into these mills the first machine which did away with all hand work in the manufacture of paper.

Baltimore furnished five views :

1. " Baltimore Exchange " (see page 259).

A brick building dating from 1815, and still standing. The wings were occupied by the branch of the United States Bank and the Custom House. In the large room under the dome the merchants of the city met to make their various transactions.

2. "Baltimore Court House " (see page 266).

This faced Lexington Street, one side being on Monument Square. It was built of brick and stone in 1808, at a cost of $150,000. A year ago it was demolished.

3. "University of Maryland " (see page 275).

The University dates from 1812. The building, a view of which appears on tea cups, is still standing.

4. "Baltimore Alms House."

The Alms House was situated at Calverton, on the outskirts of Baltimore. One of its buildings was originally the residence of Dennis A. Smith. Here the paupers of the city were taken care of from 1823 to 1866. Views of this building are found upon the various articles of a tea set.

5. "Masonic Temple," on a pitcher.

The White House.

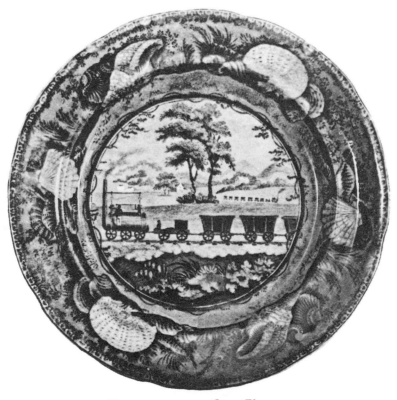

Baltimore and Ohio Railroad.

The " Baltimore and Ohio Railroad " appears upon two plates. Upon one is printed an old-fashioned railroad train. The engine drawing it is of the type invented by George Stephenson in 1825. The cylinders are vertical. No engines of this particular design were used in this country. This inclines me to believe that these plates were sent over here before or at the time of the laying of the first rail of the Baltimore and Ohio Railroad, July 4th, 1828.

The other view (illustration, page 283) shows one of the stationary engines which were placed at all heavy grades in the early days of railroading. The puny little engine shown on the plate just described was barely able to draw its load on a level ; so all grades had to be overcome by the aid of a stationary engine similar to the one shown on the plate.

Of the neighboring city of Washington four dark blue ceramic pictures are found.

One of these, a view of the city, has little historic value, for the plate represents a purely imaginative picture of the city, river and surrounding country. On two of the others the Capitol appears (illustrations, pages 264, 265); while the last bears a crudely printed sketch of the White House.

On tea sets, plates and dishes are found four views of " Mount Vernon " (illustration, page 65), a favorite

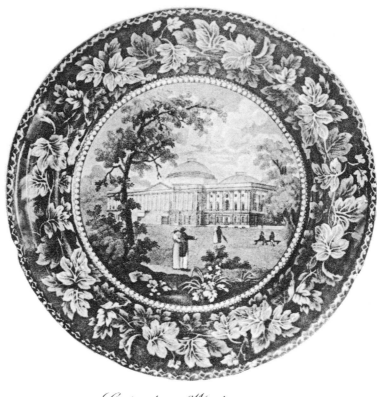

Capitol at Washington.

pilgrimage from the time its owner handed in his resignation as Commander-in-Chief of the Continental Army to the present day.

Only two of the great buildings and institutions of the South, as far as I know, appear upon this Staffordshire pottery. The hardships of travel and the distances involved rendered it a costly undertaking to send artists to this section of the country simply to

Capitol at Washington.

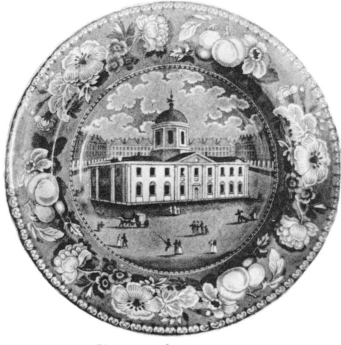

Baltimore Court House.

furnish decorations for this cheapest kind of table-ware.

Upon one side of a gravy tureen we find the Charleston Exchange (illustration, page 63). This venerable building, now used as the Post Office, was erected by an Act of the Assembly in 1761, at a cost of £44,000. The materials used in its construction were largely imported from England. While the city was occupied by the British troops during the Revolution, the lower story was used for a military prison. Among those confined here was Isaac Hayne, whose cruel and uncalled-for execution drove many hitherto Royal sympathizers to the Continental ranks. In 1791 its main hall was the scene of the concert and ball given to President Washington. On this occasion the ladies wore, interwoven in their headdresses, decorated head-bands of white ribbon, upon which were painted the head of Washington and the words, "Long Live the President." The buttons on the coats of the gentlemen present were engraved with a similar inscription.

The other side of this gravy tureen bears a picture of the United States Branch Bank at Savannah (illustration, page 275).

Probably for reasons similar to those just given very few views of the country beyond the Alleghany Mountains found their way to Staffordshire. A series

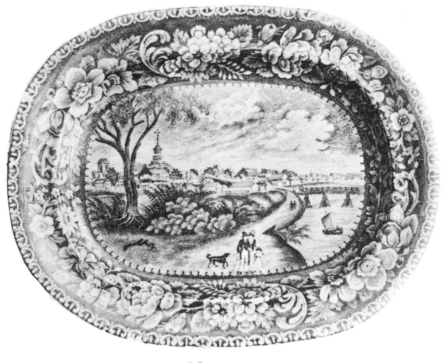

Columbus.

of platters shows interesting views of the cities of Chillicothe, Columbus, Detroit, Indianapolis, Louisville (illustration, page 70), and Sandusky (illustration, page 289).

These platters, together with the plates showing views of Albany, Fishkill, Hobart Town, Philadelphia and Washington, all with the same border of large flowers, belong to the same set made by an unknown potter.

Closely associated with life on the rivers pictured

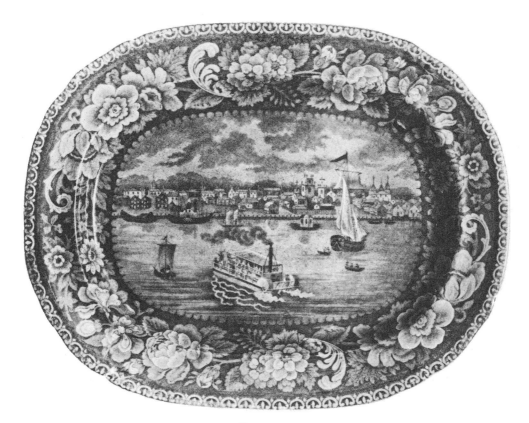

Detroit.

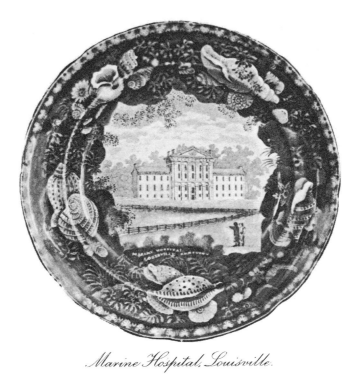

Marine Hospital, Louisville.

on these platters was the Marine Hospital at Louisville. This institution was conducted by the United States Government, so crying was the need for a place where those engaged in inland navigation could receive medical care when sick and disabled.

The State of Kentucky furnished one other view, the Transylvania University at Lexington. This was the first educational institution incorporated west of the Alleghanies. It dates from 1783. In 1785 its home was in a dwelling-house at Danville, whence, three

years later, it was removed to Lexington. An early prospectus gives the cost of tuition as "five pounds per year, one-half cash, the other in property. Boarding nine pounds a year in property, pork, corn, tobacco, etc."

In 1817 the building shown in the illustration was erected and the University was in a flourishing condition. Its excellent law and medical schools contributed largely to the development of the Western States. Just before the Rebellion the University commenced to retrograde. In 1865 it was consolidated with the University of Kentucky.

The limited room at my disposal prevents me from calling attention to the various types of steamers and ships, coaches and wagons and objects incidental to life at the time, which embellish the foreground in many of the views illustrated in the preceding pages. Lack of space also causes me to omit the long list of the sources of information whence the facts stated in the text have been gathered. It must be sufficient to say that the historical information has been gleaned almost entirely from contemporaneous newspapers, periodicals, guide books, directories and books of travel.

Probably for the reason that its real value in picturing former scenes has not been understood and appreciated, little of the historic Staffordshire ware is

found in the rooms of our Museums and Historical Societies. Owing, however, to the foresight and generosity of Mr. William C. Prime, a large number of pieces of this ware can be seen in the Trumbull-Prime collection of Pottery and Porcelain which fills the beautiful Art Building on the historic campus of Princeton University.

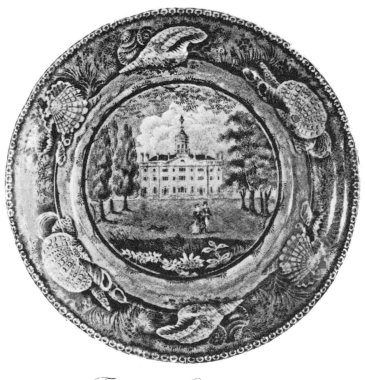

Transylvania University.

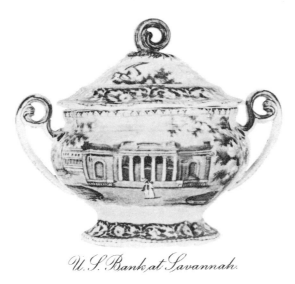

U. S. Bank at Savannah.

THE STAFFORDSHIRE POTTERS

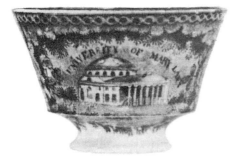

IN 1828 the potteries of Staffordshire were the largest in the world, some fifty thousand persons directly and indirectly obtaining their livelihood from them. Staffordshire was naturally adapted to this industry. The climate was dry and salubrious, and the proximity of its coal mines to its unrivaled beds of clay made its natural advantages unsurpassed. The neighboring

275

country furnished nearly all the materials required by the potter. The woods provided timber for the making of crates—by no means a small item, for five-sixths of the wares produced here were shipped to foreign markets. Many well-known firms of engravers and color makers were attracted to the towns. Paper mills in this district supplied the tissue paper required for the printing and the coarser grades of packing-paper.

There were several hundred potteries, but the owners of only eight appear to have deemed it worth their while to make special attempts to secure the American trade by exporting the dark blue wares * calculated to appeal to the national pride of their purchasers.

Very little can be learned of these men from ceramic history, yet some of their personal characteristics can be gleaned from their works.

Of Spencer Rogers, of Longport, little is known save that he was a successful potter. From the many blue printed pieces of earthenware found in this coun-

* Many unsuccessful attempts have been made in recent years to reproduce the dark blue used in printing this historic ware, whose richness and depth of coloring baffles our modern potters. A strange and remarkable characteristic of this coloring is that, while the observer is attracted to it on account of its exceedingly rich and pure blue coloring, yet, when the pottery is closely compared with another blue object, the former invariably assumes a decided purple tint.

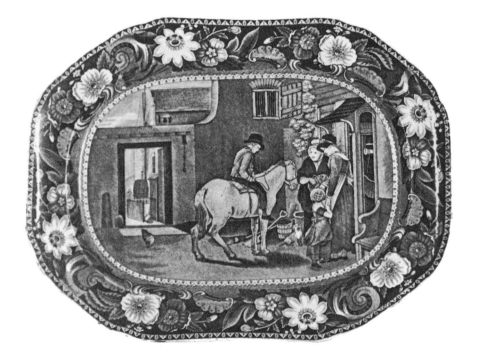

The Errand Boy.

try bearing the impressed mark, ROGERS, it is safe to assume that he did a large export trade. His contribution to Americana consisted of a view of the Boston State House.

The firm of Wm. Adams & Sons, of Tunstall, was established in 1786. Their wares sent to the American market invariably bear the mark here shown. This firm appears to have made little effort to attract the fancies of purchasers in this country, for, as far as we know, only two designs from their factory have national interest (illustrations, pages 224, 293).

The productions of Wood certainly stamp him as appreciative of the beauties of nature, for the majority of his wares are covered with views of picturesque scenery.

The pottery of the Ridgways is noted for the quality of the material and brilliancy of the glaze, and the decorations bear testimony to the humanitarian spirit which enabled them to see in our great buildings devoted to charitable purposes the "Beauties of America."

The productions of the Messrs. Clews with regard to coloring and beauty of design stamped them as finished and artistic workmen. Their reproductions of the pictures of Sir David Wilkie,* the famous Scotch artist,

*The painting of the "Errand Boy" was first exhibited in 1818. It became the property of Sir John Swinburne, Bart. The engraving from which Clews obtained his subject was made several years later.

and also of Rowlandson's drawings illustrating the popular "Tours of Dr. Syntax," were unequalled.

Strange as it may seem, these two sets found little sale in England, They were evidently made for the market on the other side of the water.

Stevenson's work is chiefly remarkable for the mathematical exactness with which the prints were transferred to the earthenware, which, on account of the scenes it pictured, decorated many an old-time kitchen such as James Russell Lowell described in "The Courtin', " where

> "The wa'nut logs shot sparkles out
> Toward the pootiest, bless her,
> An' leetle flames danced all about
> The chiny on the dresser."

His earliest efforts were crude. The work upon pieces bearing the vineleaf border was of ordinary workmanship, although interesting on account of the rare scenes reproduced. The oak-leaf set was a great improvement, both in treatment of design and coloring. Stevenson's final series, made in association with Alcock's, was artistic in design and very delicate in color.

T. Mayer evidently made only one set for this country, and from the rarity of his works it is probable that he met with slight success.

The works of Joseph Stubbs have no distinguish-

ing characteristics except their border. They vary greatly in richness of coloring as well as in design.

As the energies of these men were chiefly devoted to supplying the most ordinary kind of pottery, they attracted little attention from English writers on Ceramics. Although his efforts brought him a fortune, bare mention is made of Joseph Stubbs. He founded the factory at Dale Hole in 1790, which he conducted until 1829, when he retired. He died in 1836. In 1829 he was spoken of as having been "long esteemed for his excellencies of character." Very few of the pieces decorated with American designs made at his pottery bear the maker's name, probably for reasons stated in previous pages.*

In 1829 Stubbs's factory was purchased by T. Mayer, one of a famous family of potters. Mayer had previously long occupied the factory at Clive Bank, Stoke-on-the-Trent, which was one of the oldest potteries in England. It had been established by a contemporary of Whieldon, D. Bird, who was renowned for the agate buttons, knife hafts and salt glaze that he manufactured, and which brought him wealth.

T. Mayer's contribution to Americana comprised the "Coat-of-arms of the States" series. A rather artistic border of trumpet flowers was selected by him to en-

* Only the marks on the pieces treated in these pages are described in this chapter.

circle these pieces. In addition to the impressed circular mark, "T. Mayer, Stoke, Staffordshire," a design printed in blue, showing the American eagle, was also used.

The firm of Messrs. J. & R. Clews secured the factory at Cobridge in 1811, founded in 1808 by Messrs. Bucknall and Stevenson. At first they manufactured only the ordinary cream-colored wares, but after a few years they turned their attention to blue printed pottery. The firm was prosperous and was in existence in 1829. After the firm was dissolved Mr. James Clews came to this country, in 1836, and attempted to establish a pottery at Troy, Indiana. The poor quality of the clay and the utter impossibility of securing the requisite number of skilled workmen baffled this enterprise and entailed a severe financial loss. He returned to England, where he died in 1856. The dark blue earthenware of Clews is easily distinguished by the excellence of the workmanship and brilliancy of coloring. Of the various borders used upon the plates sent to the American market, possibly the most beautiful is that on the Wilkie set, in which the passion flower predominates. The fruit which appears on the border of the " States " plates suggests the possibility that the superb

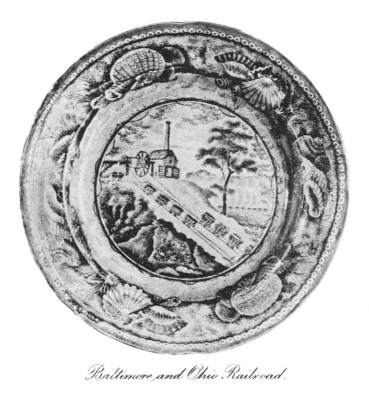

Baltimore and Ohio Railroad.

flower and fruit borders (illustration, page 266) which surround four unmarked American views may be also the work of these men. The supposition is strengthened by the similarity of the unnatural cloud effects in these pieces to the one shown in the illustration on page 120. The appended mark was used by the Messrs. Clews, though their wares were frequently without the potter's name.

In 1814, upon the death of John Ridgway, who had established his factory in 1794, his two sons formed a

partnership, which was not dissolved until 1830. Their two potteries were situated in Shelton and Hanley. The Ridgways held a high place among the Staffordshire potters, and produced a superior grade of pottery, as well as the kinds described in these pages. The "Beauties of America" series comprises all the ceramic views of America made by them. The border employed on this set consisted of a series of medallions in which a rose rests in the centre of a large rose-leaf. Their mark was printed in blue. After their separation the two brothers exported many of the lighter colored wares picturing American scenes.

The name of Stevenson had long appeared in the annals of the potteries of Staffordshire. As far back as 1686 mention is made of one John Stevenson practicing his trade at Burslem. In 1786 the firm of Charles Stevenson & Son was mentioned in the list of potters at Burslem. In 1802 Stevenson and Dale started a pottery at Cobridge. In 1815 Dale withdrew, and Ralph Stevenson conducted the works under his own name until 1834, when the firm became R. Stevenson & Son. This firm went out of existence in 1840. There are few records of this Ralph Stevenson ; yet to him more than to any other of the Staffordshire potters are we indebted for faithful pictures of our old buildings and

pleasure-grounds. His earliest efforts, the crockery bearing the vine-leaf border and chiefly decorated with views of New York, are impressed with the mark STEVENSON. In some cases they have also the blue printed letters, R. S. or R. S. & W.

His next series is decorated with the oak-leaf border, and bears on the back the title, printed in blue in a scroll, accompanied by initials, R. S. W.

These are known to be the work of Stevenson, for on the back of the small Scudder's Museum plate, with the white edge, is found the impressed mark, Stevenson, as well as that of R. S. W.

Another of Stevenson's plates (see page 125) bears an elaborate mark. Williams cannot be identified with certainty. The name is not found among the potters of Staffordshire. A

well-known family of potters named Williams had long lived in Bayard Street, New York, where they made crockery of the coarsest description. In 1830 R. M. Williams advertises as a dealer in and importer of china and glassware, 183 Washington Street. From the fact that New York views are used so extensively on Stevenson's china, the probabilities are that R. M. Williams acted as Stevenson's American agent and supplied the

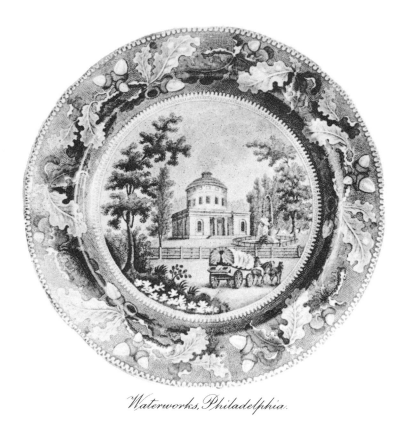

Waterworks, Philadelphia.

potter with designs that would be sure to appeal to the American people. The R. S. & W. mark was undoubtedly added out of courtesy to Mr. Williams. Indeed, it is not uncommon to find printed ware marked with the name of the dealer who acted as agent in this country. This custom prevails to-day.

Stevenson used a number of copper-plate engravings made from sketches by C. Burton, a New York artist, who drew pictures of many important buildings and interesting scenes of every-day life in New York.

A number of R. Stevenson's views in blue were made from drawings which have been reproduced in no other form. All of these views seem to be by the same artist, for their general treatment as well as the position of the figures in the foreground are characteristic of Burton.

While working with Alcocks the mark below was used on the series decorated with the following borders :

1. Roses and other flowers (illustration, page 77).

2. Large roses and rose-buds (illustration, page 39).

3. Scrolls, skilfully intermingled with various flowers, among which are roses, field daisies and clover (illustration, page 164).

The names of the views in these three series, as a rule, are printed in blue upon a ribbon looped across an urn, though in some cases special designs were made for the title, as shown on the back of the plate as well as the platter bearing a View of "New York from Heights near Brooklyn" (illustration, page 164).

The name Wood had long been associated with the potteries of Staffordshire before Enoch Wood, known as the "Father of the pottery," established his own factory at Burslem in 1784. Six years later James Cauldwell became his partner, and the firm of Wood

& Cauldwell was formed. Two years hence the latter withdrew, and the firm was changed to E. Wood & Co. In 1818 Wood's three sons were admitted, and the name was again changed to that of Enoch Wood & Sons, who continued in business until about 1846. Their factory, the largest in the district, occupied the site which had once been covered by five potteries. They also worked two other potteries in a different part of the town. Enoch Wood's talents were not restricted to his workshop. He was a mechanical engineer, and in 1806 made some improvements which tripled the power of the steam engine constructed upon his premises. Adjoining his factory he erected a large circular bath, amply supplied with water of an even temperature. His love of the beautiful caused him to have the interior walls of this building most elaborately decorated with marine views and beautiful bits of landscape. The public was allowed in this bath upon the payment of a small fee. On the fiftieth anniversary of the commencement of the Trent and Mersey Canal, the first clod for which was cut by Josiah Wedgwood, the potters of the neighborhood met to commemorate this event and to pay their respects to the memory of this famous man. The chair was filled upon this occasion by Enoch Wood, who, after delivering an address upon the life and merits of his illustrious friend, exhibited a

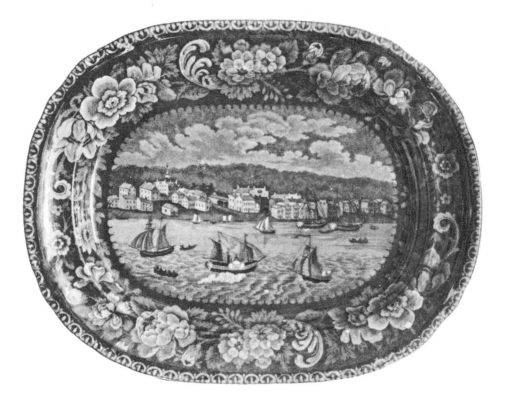

Sandusky.

collection of ceramics which well illustrated the great changes made in the potter's art during the past one, hundred and fifty years. This collection he placed in a museum in the town.

Twice he was Chief Constable (Mayor) of Burslem, and was most prominent in the affairs of his church. His sons bore out the good reputation of their father, and were men of great ability, high character and benevolent dispositions. The Woods devoted themselves almost entirely to the foreign trade, and with such success that their wares followed the British flag to all parts of the world. No other potter's works are so well known in this country.

Besides the numerous American designs, many pieces decorated with views of foreign lands were also sent here. In most cases these pieces bear no mark except the title, yet the borders with a stray mark here and there identify them. Many of the American views of uncertain origin are probably the work of the Woods.

The borders most commonly used by Wood were:

1. Hollyhocks, iris and grapes on the La Grange and other French views (illustration, page 131).

2. Sea-shells surrounding a circular opening (illustration, page 35).

3. Shells and marine flowers. An irregular open-

ing arranged to give the effect of a view from a grotto (illustration, page 117).

4. Various flowers, among which the double poppies are most conspicuous (illustration, page 147).

5. Small flower design; roses, thistle and shamrock, found on hollow ware.

Single pieces, such as the "Landing of the Pilgrims" and "Boston State House," have their own special borders.

The impressed marks were on some pieces, the circular device here shown, and on others WOOD only.

The Woods were also celebrated modellers. Indeed, the earliest mention of the senior member states that he executed in 1781 a bust of John Wesley. In 1818, they put upon the market a superb series of busts, among which were well-modelled portraits of Shakespeare, Wellington, and the crowned heads of Europe. Their contribution to America in this line was a bust of Washington (shown on title-page).

Upon the back is impressed

WASHINGTON
Born 1732
Died 1799
ENOCH WOOD & SONS
1818

Beneath this mark is a large American eagle in re-

lief, with wings extended. Its artistic modelling and beauty of color makes this piece so far superior to the coarse and clumsy Staffordshire statuettes of Washington and Franklin which, though unmarked, have been attributed to this potter, that it is hard to believe that the latter originated at the pottery of these celebrated workers in clay.

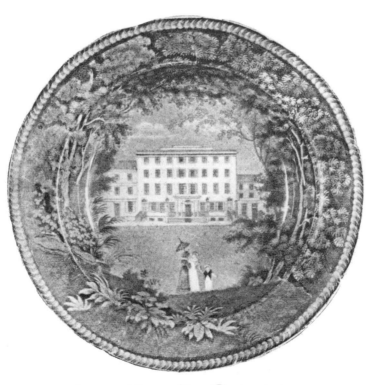

United States Hotel, Philadelphia.

APPENDIX

A

THE " CINCINNATI CHINA "

THE "Cincinnati china" (see frontispiece) deserves more than a passing notice, for it not only marked the introduction into America of the patriotic emblem on china, but it possesses the distinction of having once belonged to General Washington.

The Custis family, who inherited it, always believed that this set was a present to Washington from the members of the Order of the Cincinnati, yet the records of this Society bear no testimony to this effect. Another tradition says that it was ordered for Washington by the French officers who served under him in the Revolution; still it seems improbable that when the factories at Sèvres were doing such splendid work so noteworthy a gift should have been ordered from China rather than from the potteries in France.

Careful searching leads me to the belief that this set was brought from China by Captain Samuel Shaw, a Bostonian of good family and fine classical education.

To this officer and to General Knox belong the honor of organizing the Order of the Cincinnati, May 13th, 1783. Captain Shaw acted as Secretary of the meeting at which the Order was instituted and the Insignia adopted. The design for the latter was furnished by Major L'Enfant, an accomplished engineer and a skilled draughtsman, who was at once sent over to France to have the badges modeled under his immediate supervision. Captain Shaw was the trading agent for the owners of the "Empress of China," the first vessel to sail from this country directly to Canton, the only open port of China. In company with his friend and brother officer, Captain Thomas Randall, one of the military family of General Knox, he sailed from New York February 22nd, 1784, and reached home May 11th, 1785.

The following is an extract from the journal of Captain Shaw, written while he was in Canton:

"There are many painters in Canton, but I was informed that not one of them possesses a genius for design. I wished to have something emblematic of the institution of the Order of the Cincinnati executed upon a set of porcelain. My idea was to have the American

Cincinnatus, under the conduct of Minerva, regarding
Fame, who, having received from them the emblem of
the Order, was proclaiming it to the world. For this
purpose I procured two separate engravings of the god-
dess, an elegant figure of a military man, and furnished
the painter with the copy of the emblem which I had
in my possession. He was allowed to be the most
eminent of his profession, but after repeated trials was
unable to combine the figures with the least propriety,
though there was not one of them who could not copy
with the greatest exactness. I could, therefore, have
my wishes gratified only in part."

Additional evidence that this china was ordered in
this year may be derived from the fact that General
Knox owned some pieces of china decorated with the
same emblem and bearing his initials. It seems reason
able to believe that his pieces were brought over by
Captain Randall as an appropriate gift to his beloved
commander, and that upon the arrival home of these
two old soldiers the "Cincinnati china" was then pre-
sented to Washington and Knox.

An advertisement in the "Baltimore American" of
August 12th, 1785, settles positively the date of this
design, for it announces that among numerous varieties
of china which formed the cargo of the "Pallas," just
arrived from Canton, were "evening blue and white

stone china cups and saucers painted with the arms of
the Order of the Cincinnati." A letter from Washing-
ton to his friend, Tench Tilghman, expressed a desire
to secure these if possible. The fact that this is the
only allusion to this emblem found in the inventories
and detailed advertisements of the cargoes of vessels in
the China trade assures me that the cups and saucers
mentioned were part of the order given by Captain
Shaw which had been left behind uncompleted, and
were sold to the supercargo of the "Pallas," the next
vessel after the "Empress of China" to leave Canton
for this country. The absolute uniqueness of these
pieces proves that this set, though bearing a design
calculated to appeal so strongly to the numerous mem-
bers of the Cincinnati, was never put upon the market,
but was the result of a definite order for a special
purpose.

This set was mentioned in the will of Martha
Washington, and pieces of it long reposed at Mount
Vernon and Arlington. The latter was a veritable
treasure-house of relics of Revolutionary days, collected
by Washington's grandson and adopted son, George
Washington Parke Custis. The latter, at his death,
left them to his daughter, Mary Custis, the wife of
General Robert E. Lee. The sudden advance of the
Federal troops at the outbreak of the war caused the

hasty departure of Mrs. Lee from Arlington, and the priceless Washington relics, among which are some sixty pieces of this set, collected and cherished by Mr. Custis, were seized by the Federal forces and now repose in the National Museum at Washington.

The pieces from which the illustration was taken were formerly part of the collection of Governor Caleb Lyon, who was one of the earliest collectors of ceramics in this country. A frequent and welcome visitor at Arlington, he probably obtained the specimens from Mrs. Lee, though it is possible that his intimate friendship with Mr. Lincoln allowed him to secure for his magnificent collection of pottery the pieces which on many state occasions had graced the table of the "Father of his Country."

B

"THE CHERRY TREE STORY"

DURING the last decade noteworthy progress has been made in tracing out the true history of this nation's origin and development, and yet, as the truth has been extracted, it has been gained at the expense of shattering many of the idols of our childhood days, with the result that we find ourselves bereft of many of the quaint bits of historic fiction which, so attractive to children, stamped themselves indelibly upon our memories. Among these, "The Cherry Tree story" has been dismissed as originating in the fertile mind of Mason L. Weems, an itinerant clergyman.

The latter wrote a life of Washington, which was published in 1804 and had a wide circulation. In it, for the first time, appeared this universally accepted story of Washington's boyhood. It must be said that appearances, hitherto, have all pointed to the fact that

Mr. Weems originated the story so dear to all Americans, and which has served for many years as a practical lesson in ethics, for no other earlier record of this scene had come to light. In a letter from the author to a friend, Mr. Weems admits introducing, with the idea of the moral effects to be produced upon the reader, several stories which not only embellished the history, but which he hoped would have a beneficial effect upon the reader.

With the earnest hope that this story may be proven to have been current talk many years before it appeared in print, I have inserted into this text the illustration which appears opposite page 3. The subject of the decoration instantly appeals to all Americans ; yet, from the eminent authorities who have thoroughly sifted out the facts in the story of "George Washington and his Hatchet," I feel that this bit of stone ware will be received with some skepticism. The facts concerning it are as follows, and the reader must draw his own conclusions :

First. The ware is of the crudest description and of the kind commonly made in Germany during the period from 1770 to 1790. Its genuineness is unquestioned. The decorations are beneath the glaze, which fact proves that they have not been added in recent years.

Second. The youth is dressed in clothes similar in color to those of the Continental uniform. He wears a tri-cornered blue hat, blue coat and buff trousers. The coat and trousers are of the cut worn by children. Homespun stockings appear in the place of leggings, and the hatchet is largely in evidence.

Third. The house is shown and a cut-down tree; above the latter are the crude letters "G. W.," and below these the rough numerals "1776." The juxtaposition of the letters, numerals and tree certainly prove that they were purposely intermingled.

The facts stated above leave little doubt that upon this bit of coarse earthenware is found a quaint and rude representation of this popular story. Yet, interesting as this is, as a specimen of historical pottery this mug has a far greater value, for upon the lower edge, as was the custom upon this special class of wares, were placed the initials of the artist (or owner), also the date 1776, which unmistakably stamp this piece as made in this year. Only one more criticism can be made upon the usefulness of this piece in dating back the origin of "The Cherry Tree story"—namely, it may be said that this sketch merely represents a European scene; therefore, the mingling of boy, hatchet, tree, initials and date must be a remarkable coincidence. In answer to this, there can be pointed out on the vine

which composes part of the decoration, two parrots, surely not European birds, but at the time attributed by naturalists to America, both North and South. The last point certainly disarms all criticism upon the ground of coincidence.

It is a well-known fact that many events of ancient history have been perpetuated solely by the curious drawings and hieroglyphics of the potter. May not this crude sketch, with its accompanying dates, prove this great moral lesson to have been common talk at the time when King George III took advantage of the venality of certain German princes and hired from them troops, the flower of Europe, to fight in behalf of a cause in which he was unable to enlist the services of enough of his own subjects, so unpopular was the war in England ?

To the credit of the German people it must be stated that this selling of troops was most bitterly resented in many parts of the country, and the successes of Washington were hailed with delight by this liberty-loving people, then suffering from the tyranny of their princes. Certainly, it does not seem improbable that, in view of the interest the German people took in our struggle for liberty, this story was wafted across the sea and reached the ear of some potter, who then clumsily pictured it upon a mug of stoneware, adding

to it the date, 1776, as the year which then, as well as now, is most closely associated with Washington.

Such is my plea for the preservation of ''The Story of George Washington and his Hatchet.''

C
LIST OF POTTERY

I N the following pages is to be found a description of
the various pieces of dark blue Staffordshire ware,
whose decorations relate to our nation's history,
and which to my personal knowledge are still in exist-
ence. An endeavor has been made to make this list
concise and compact. The numerals on the right refer
to the pages where illustrations of the pieces may be
found. For purposes of identification, the borders are
briefly described. In the cases of the pieces which
have not been reproduced whenever it has been possi-
ble to identify the maker by mark or inference I have
done so, using the following abbreviations: R., Ridg-
way; St., Stevenson; S., Stubbs; W., Wood; C.,
Clews; A., Adams; Rs., Rogers.

APPENDIX

PAGE

APPENDIX

 This was evidently a close copy of Stevenson's plate. The design varies, however, in some slight details : it lacks the subterranean entrance to the theatre, and also shows more tiny figures on the sidewalk in front. The Verreville Pottery, Glasgow, was built for a glass house in 1779. In 1806 it was purchased by John Geddes, who in 1820 commenced the making of earthenware there, which he continued until 1835.

APPENDIX

INDEX